HANDPAINTING FABRIC

HANDPAINTING FABRIC

FABRIC

EASY, ELEGANT TECHNIQUES

MICHELLE NEWMAN & MARGARET ALLYSON

WATSON-GUPTILL PUBLICATIONS / NEW YORK

Senior Editor: Joy Aquilino
Project Editor: Elizabeth Wright
Designer: Barbara Balch
Graphic production: Ellen Greene

First published in 2003 by Watson-Guptill Publications,
a division of VNU Business Media, Inc.,
770 Broadway, New York, N.Y. 10003
www.watsonguptill.com

Library of Congress Cataloging-in-Publication Data is available
from the Library of Congress.

ISBN 0-8230-1626-9

Manufactured in China

First printing, 2003

1 2 3 4 5 6 7 8 9 / 10 09 08 07 06 05 04 03

Disclaimer: The authors and publisher have made every effort to
ensure that all the instructions given in this book are accurate and safe,
but they cannot accept liability, whether direct or consequential and
however arising. If you are pregnant or have any known or suspected
allergies, you many want to consult a doctor about possible adverse
reactions before performing any procedures outlined in this book.

ACKNOWLEDGMENTS

People pass in and out of our lives for a reason, and many times they leave an indelible impression. I've been quite blessed with mentors and muses, including teachers who guided me, expanded my horizon, and showed me a new way to think. These range from my 10th grade art teacher at Miami Beach High, Louis Marinacio, who introduced me to batik and placed a *tjanting* tool in my ready hands, to Jason Pollen, chair of the textile design department at the Kansas City Art Institute.

I am grateful to my mother, Celia Newman, for setting a good example of creativity and courage; my aunt, Helene Silverston, who made an everlasting impact by exposing me early on to beauty, glamour, and good design; my grandfather, Saul I. Kenholz, for his gutsy independent spirit; my best friend of 20 years, Dr. Dennis Blackburn, for his constant support and encouragement; designer Mary McFadden for the honor of inviting me to participate in her couture collections; the late Stanley Marcus for his personal and commercial interest in my work; Bob Rogers for putting me in front of a camera on KENS TV; Uvaldina Cortez, who so skillfully sews my fabrics into items of beauty; and Peter Melendy for enriching my life with the love he bestows upon me.

—Michelle Newman

What could be more fortunate than to make a living doing what one loves? Such a blessing is mine, because I so enjoy the contemplation of art and all the elements of the writing process.

I'd like to thank my mother, Golda Cooper, whose command of the language and love for textiles inspired me from the beginning.

—Margaret Allyson

We'd like to thank our models, Tessa Gonzalez and Emily McMichael, and our editors, Joy Aquilino and Elizabeth Wright, for their patience, grace, and good guidance. Special thanks to Teri Blond for her brilliant photo styling and fabulous energy.

Several companies supplied products for these projects, making our work easier and more pleasant. Special mention should be made of Michael Katz and Kim Meyer of Jacquard Products for their help with text and photography.

—Michelle and Margaret

CONTENTS

FOREWORD

For the last fourteen years, I have enthusiastically presented and demonstrated a wide range of decorating and remodeling projects on television. Prior to my television career, I was involved in the world of fashion as a merchandise coordinator and buyer for a fine department store and as a sportswear designer. All these arenas are filled with various materials, scales, patterns, and colors.

My goal as a television host and correspondent has always been to present clever ideas that could inspire and hopefully empower the viewer to adapt them to his or her own needs, circumstances, and personality. I hold strongly to the belief that you can do almost anything with your hands if you are curious! Great personal satisfaction is realized in the process of attempting something new. For me, the *process* holds the most fun.

Michelle has been a frequent and treasured guest on my show on HGTV. I am continually impressed with her enthusiasm and passion for her craft as well as her constant reinvention of creative venues for the application of paint on fabric! The exquisite designs shown in this book are truly inspiring, and techniques described are easy to follow. I share Michelle and Margaret's hope that readers will be empowered to attempt and enjoy the process of imprinting their own style while keeping "their eyes open" for their own designs for creating fashions they will be proud to wear and accessories they will be proud to share!

—Kitty Bartholomew, host of HGTV's *Kitty Bartholomew: You're Home*

INTRODUCTION

In idle chatter, I've said that I discovered Michelle Newman. That's not true, of course. She had discovered herself long before that day, and so had dozens of her clients.

I grew up watching my grandmother, a true folk artist, make fantastic quilts out of scraps and watching my mother sew precisely constructed garments. I tried to follow in their footsteps, and I added weaving, spinning, and raising silkworms to the mix. But words seemed to be my true medium, and I eventually found my niche in publishing. I was editing a national arts and crafts magazine when Michelle and I met at the International Quilt Festival. I didn't exactly stalk her, but I did follow her around awhile because of the vest she was wearing—and a magazine editor is notoriously hard to impress. We began publishing her designs right away.

At that time (the mid-nineties), the overarching goal for fabric painting in the craft world seemed to be creating bigger roses and cuter bunnies. It was not a stimulating period. Michelle's work changed all that. Some of her techniques use the same products fabric painters are accustomed to

using. Many are new takes on familiar methods, and all are accessible and nonthreatening. Plus, she has the fashion savvy to blend her sleek and stylish motifs into timeless, classic pieces—kimonos, cocoons, tunics, and scarves. I've never known her to paint a design on a big white sweatshirt.

When Michelle Newman and her opulent designs entered the craft world, it was as if a large window had been opened in a pleasant but stuffy room.

Michelle is the artist whose designs and techniques this book demonstrates, and I am the book's writer. I'll be telling you how to do what she does. If you're a beginner, have no fear. You can do anything and everything in this book. There's nothing hard about these techniques, and only a couple of them require you to "color inside the lines."

It is almost impossible to dye a length of ombré velvet or sponge-paint a silk scarf and wind up with something that isn't beautiful. You might want to stop right there or go on to add stamped dragonflies, freehand swirls, or silkscreened squares.

We'll talk about materials, methods, and the design

process. We'll show you how to make some specific projects, both wearables and home décor items. You can use the book in several ways: to make a project tonight with what you have on hand, to duplicate one of the projects, or to learn a new technique to add to your repertoire.

It was a challenge to give this book a name. For the art of coloring fabric, we have no better terms than painting and dyeing. Yet within the scope of these flimsy terms lie worlds of wonder. As you browse the pages of this book, you'll glimpse this vast and varied terrain and realize, once again, the limitations of the language and the power of human imagination.

—Margaret Allyson

MATERIALS AND TOOLS

You can create fantastic fabrics with a very short list of supplies and equipment. If you sew, craft, or paint, you'll already have most of what you need. The materials we describe in this chapter can be used for more than twenty different techniques, and you don't need them all immediately. Each is a building block.

This book could inspire you in different ways. You might fall in love with a particular project or technique and want to learn how to do it. Practicality might guide you: put the supply of acrylic paints or yards of black velvet you have on hand to use. No matter how you first approach handpainting fabric, here's an overview of the materials and tools you'll use on your adventure.

FABRICS

Michelle works mainly with natural fibers, and you'll probably want to do the same. They take dyes beautifully and evenly, and also have a better "hand," which is a term frequently used by textile people to describe the way a fabric feels—smooth, crunchy, slippery, crisp, or soft. It refers to your tactile experience of a fabric. Natural fibers feel good, catch the light just so, and age exquisitely, not to mention the fact that you'll be so impressed by what you can do, you'll be glad you used a high-quality fabric. Don't practice on that poly/cotton blend! Your "practice" piece is going to be a big success.

This may sound like an expensive proposition, but it doesn't have to be. True, silk is pricey at most fabric stores, but several mail-order companies that cater to dyers offer many grades and weaves of silk at very affordable, even wholesale, prices. Dubious? Think as low as $3.00 to $6.50 a yard! Polyester fabrics can easily cost that much or more. Another selling point is that these fabrics—unlike those in fabric stores—have not been treated with sizing or special finishes that inhibit the absorption of dyes and paints.

If you simply have to get started tonight, you can always raid your closet. Cut up that ivory silk-noil skirt that makes your hips look so big. Now that's recycling. (If you have always hand-washed that skirt, you're ready to go. If it's been dry-cleaned, however, give it a quick suds-and-rinse in the sink. For some of these processes, you won't even have to wait until the fabric dries.)

Natural fibers, like the silk pictured here, are easy to paint and dye, and they age beautifully.

SILKS

Silk is a protein fiber produced by silkworms. Smooth silk fabrics, such as satin, charmeuse, and crepe de chine, are made of single filaments that have been reeled, or unwound, from whole, individual cocoons. This continuity gives them their glimmer. It may take ten filaments to make a thread whose size is comparable to sewing thread.

Silk noil, like denim, chambray, and similar fabrics, is woven with threads produced by spinning. Rather than being composed of unbroken filaments, noil threads are spun from short silk fibers. Silk noil feels good and takes dye well, but it lacks the light-refracting properties of reeled silks.

Be forewarned that fabric stores can play fast and loose with the word "silk," often advertising silks and "silkies" in one casual breath. Silkies can be pure polyester. The educated hand can usually detect a greasy feel in synthetics as opposed to silk, which is crisp and dry. Even the knowledgeable and seasoned fiber artist can be fooled, though, so it's a good idea to conduct a burn test—but not inside the store! Ask a clerk to snip off the tiniest strip—about 2 x ⅜". (You can do a burn test on twisted, unraveled threads also.) Take it outside. Hold a match to one

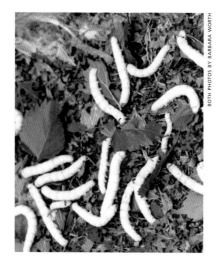

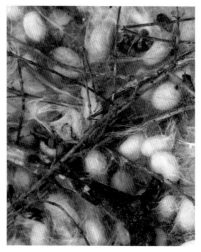

Above: *Mature silkworms, tired of eating mulberry leaves, prepare to spin cocoons.*

Below: *Silk cocoons. Moths are still inside. Note the variation in color.*

end. Be on guard: Some fabrics will flare up. Quickly douse the fire (just step on it) and examine the burned area. If the fabric is hard or beaded up, it's synthetic. If the burn test leaves you with soft, crumbly, black ash that smells like burned hair, the fabric is indeed silk.

Don't avoid silk because of those "dry clean only" labels. True, you don't want to toss your hand-dyed silk creations in with your blue jeans, but silk is quite washable and a lot sturdier than you might think. Launder a filmy scarf or blouse in the sink with a gentle detergent or a mild shampoo and rinse it thoroughly. Don't twist or wring; treat it gently. Add a few drops of vinegar to the final rinse to cut any soap or detergent residue. Roll the silk in a towel to absorb most of the water, and iron while it's still damp. Silk noil can go into both the washer and dryer on delicate settings. Exceptions are tailored or highly constructed garments. These will fare better with dry cleaning, but that's due to their structure rather than to the silk fibers. Silk can be as user-friendly as polyester. (And, no, we don't think polyester is "bad" just because it's synthetic and does not "breathe" the way silk does. We've seen some drop-dead gorgeous examples of dyed and painted polyester, and many artists love the fiber. We are both admitted silk aficionadas, however. Michelle calls one of the classes she teaches "Silk Seduction," and I raised silkworms for ten years.)

Silk fabrics range from diaphanous to heavily textured, slick to chenille. One of Michelle's signature looks is sheer, floating, white-on-white

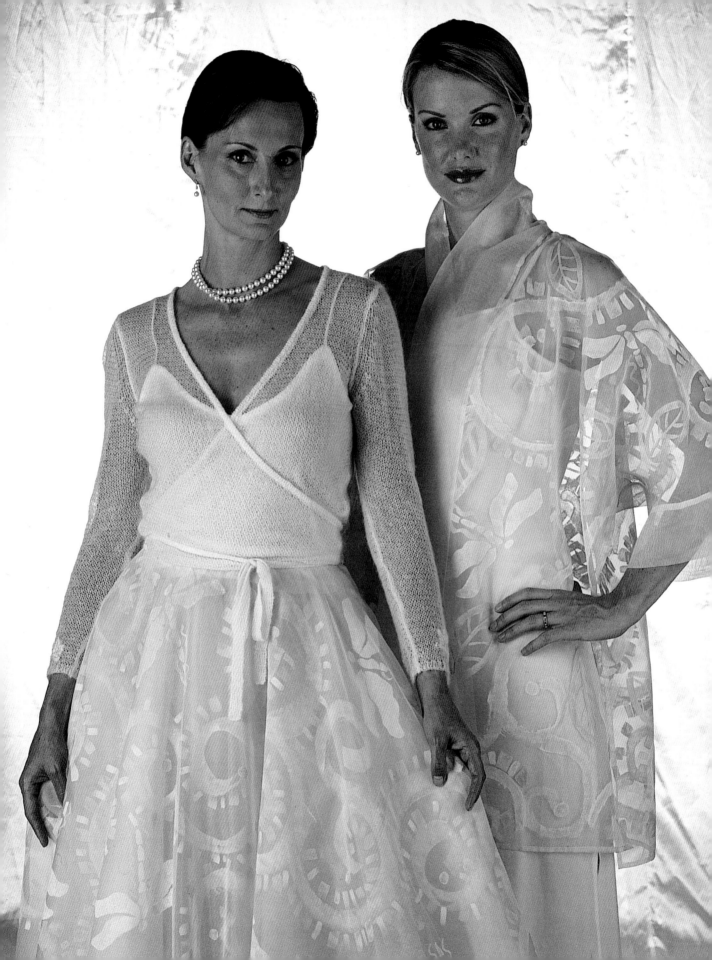

silk. She chooses silk organza for pieces in this series. It's fairly crisp and stiff, and it has some body to it. This facilitates painting, but after the fabric is washed, it loses some of its stiffness. She also uses satin georgette, another sheer, which is shimmery on one side. It's drapey, soft, and flowing. The weight of smooth silks is traditionally measured in *mommes*, abbreviated as "mm." If you are ordering from a catalog, you may see a silk described with the abbreviation 8mm, for example. This would be a very thin, lightweight fabric. Larger numbers indicate heavier silks. Of course, when you're shopping in person, this becomes irrelevant. You won't need to be concerned with weight; you'll just buy what you like.

Mail-order suppliers sell plain white silk in many different weights, textures, weaves, and patterns as well as pre-hemmed scarves and shawls. (When you want to explore an unfamiliar fabric-painting technique, try it on a scarf—they come in a vast array of sizes and shapes, and are thus perfect for experiments. And when you're finished, you have an

actual, usable item rather than a fabric swatch.) Mail-order suppliers even sell simple garments like vests, neckties, kimonos, and sarongs that are ready to paint or dye. Most will send you, for a small fee, samples of the actual fabrics.

VELVET AND VELVETEEN

Velvet, of course, is not a kind of fiber but, rather, a weave. Velvets can be composed of rayon, cotton, silk, or blends.

Velveteen is almost always cotton. For fabric painting and dyeing, natural fibers are best.

Every rule has its exception. The "mystery fibers" of rayon velvets (often multiple blends whose fiber content is poorly labeled) make one particular technique a lot of fun. When you're doing bleach discharge (described in Chapter 5), serendipity takes over. In this process, you'll be surprised to see what happens when you bleach out the color of commercially dyed fabric. Discharging several different black fabrics can produce

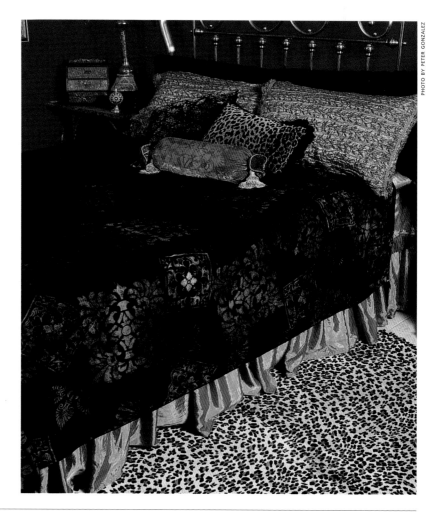

Facing page: White silk organza forms a perfect background for tone-on-tone motifs.

Right: *Transform a bedroom with the luxurious look and feel of velvet. Most of the motifs are silkscreened.*

totally different colors, depending on the fiber content and dye composition. The same is true for other dark tones as well. And, as long as we're off on this little tangent, the bleach discharge technique isn't limited to velvets; it lends itself to several other fabrics.

Even though you wouldn't normally machine wash velvet or velveteen, many of Michelle's instructions tell you to put these luxury fabrics into the washer and dryer. She's tested her techniques. Follow the directions; it'll be okay.

OTHER FABRICS

Of course you're not limited to flat-weave silk and velvets and velveteens. Cotton, linen, and wool will accept dyes and paints quite well. So will rayon and other synthetic fabrics such as polyester. We will focus mainly on natural fabrics because Michelle works with them most. Note that some paints and dyes work best on plant fibers (cotton and linen), while others work better on animal fibers (silk and wool). Likewise, some products are specifically formulated for natural fibers, as others are for synthetics. If you know the fiber content of the fabric and read the labels on the products, you will be sure you're on the right track. There is plenty of room for experimentation, and

there are very few prohibitions (using bleach on silk is one). Any "thou shalt nots" will be detailed in later chapters in discussions about specific products and processes. The painting and dyeing of fabric is a forgiving process.

Even though they're not fabrics, don't overlook using

Cotton, of course, is a natural for bedding. Michelle used wax resist and a lively palette of colors for this ensemble.

leather or Ultrasuede as a painting and dyeing surface. For wearables, accessories, and home decor, both of these can add a look of luxury, a natural touch, and an exotic feel.

PAINTS AND DYES

Although you can use crayons, markers, mud, and even berry juice to transform your plain-vanilla fabric into a unique textile, the two most popular materials for coloring and design are paints and dyes.

For some techniques, like freehand painting, you can choose either paints or dyes, depending on the design you want, the finished effect you desire, and other variables. Some techniques seem to require one medium, but you can make adjustments and use the other. An example is stamping: It's usually done with paint, but thickened dyes work, too.

The main thing to keep in mind is that dye penetrates the fabric, while paint sits on its surface. Dye won't alter the hand—the feel—of the fabric, while paint invariably stiffens it to some degree.

PAINTS

Acrylic paints are used for lots of different art and craft projects; consequently, they're easy to find and inexpensive. Art acrylics usually come in tubes because they're thick and concentrated, but they are available in a fairly narrow

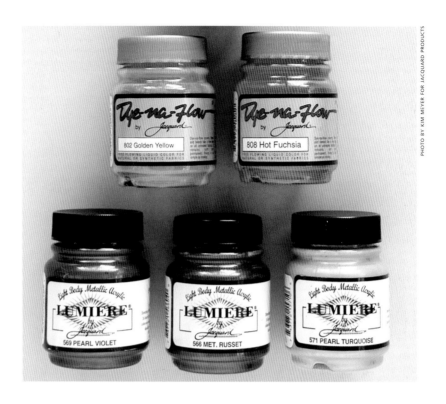

Lumiere (bottom row) is a metallic paint; Dye-Na-Flow (top row) is a hybrid: not quite a dye, not quite a paint.

range of colors because artists like to mix their own. Craft acrylics are thinner, so they are generally packaged in small jars or bottles. The array of colors is eye-popping because crafters usually want to just open the lid and start painting without the bother of mixing. Then, too, there are acrylic "fabric" paints formulated especially for work on textiles. Some acrylics are opaque. Some are transparent, providing just a wash of color without full coverage.

Craft acrylics are most often used for fabric painting, but that's just out of conven-ience. If you must paint at midnight, and all you have in the house are tubes of art acrylics, just thin them to the same approximate consistency as craft acrylics with water or textile medium and have at it.

Any acrylic paint, whether art or craft, will affect the texture and hand of the fabric somewhat, although it will do so less if you thin the paint with water or textile medium.

Acrylic is cousin to plastic. Paint thickly with acrylics, and the fabric will feel stiff. For a belt, handbag, or wallhanging, that's no problem. For an all-over design on a drapey garment, however, you'll probably want to use dyes instead.

Metallic acrylic paints will deliver dramatic effects. For one of her signature design series, Michelle uses metallic acrylics on black velvet, sometimes layering antique and bright golds, silver, pewter, bronze, copper, and gunmetal in different combinations. Metallics are good for stenciling, stamping, or silkscreening on velvets as well as flat (non-pile) fabrics and also for free-hand painting.

Pearlescent and interference paints can also be used on fabric. They contain minuscule bits of mica; pearlescents glimmer when they are applied to light-colored fabrics, and interference paints work best on dark or black fabric.

DYES

Unlike paints, dyes bond with the fibers of the fabric and do not change its hand. Dyeing is a chemical reaction—molecular bonding. Dyes penetrate the fabric rather than lying on the surface like paints. You can build up layers of dyes and still have a soft and slinky length of silk when you're done. Almost

all dyes require a "fixing" or "setting" process to lock this molecular bonding in place. Fixing can be done chemically (with soda ash, for example) or thermally (with heat). Steaming uses heat to set the dyes.

Because mixing powdered dyes can create airborne dust, use liquid dyes at first. When you're more experienced, you can branch out into powdered dyes. Michelle likes Dye-Na-Flow, a liquid product marketed by Jacquard (similar products are made by Pebeo) that is suitable for natural and synthetic fibers. It works beautifully for almost all the dye techniques we'll talk about

Above: Fiber-reactive dyes are versatile, and can be used on many fabrics.

Opposite: Working with dye can be the essence of simplicity. Working on wet fabric, detailed in Chapter 4, is previewed here. Note how colors blend to create an ombré effect.

and can be fixed or set by dry ironing or by placing the dyed fabric in a hot commercial dryer.

Silk dyes must be steamed or batched to set their color. Chapter 7, "Using Resists," carefully explains the process of steaming. Batching involves using a chemical additive, usually soda ash, with the dye and keeping the dyed fabric moist overnight. Generally, silk dyes

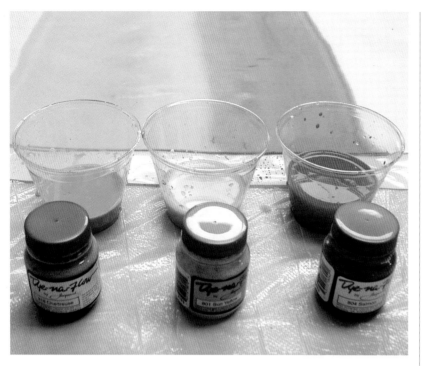

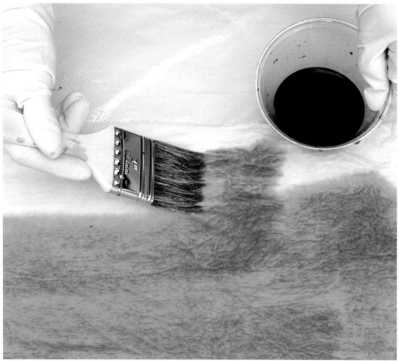

Effects," for more information).

Then, too, there are the natural dyes that have been used for centuries—cochineal from tiny bugs, and madder and indigo from plants. You may go on to work with these fascinating dyes, but we don't discuss them in this book.

The dyes we've talked about here are safe and nontoxic. Nevertheless, you should take the precautions detailed in the box above before working with any kind of paint or dye.

are differentiated by a series designation. The "H" series requires heating or steaming; the "MX" series is set by batching, which is described in more detail in Chapter 8. Michelle uses the MX series of dyes and the batching process for her "shortcut shibori" technique (see Chapter 8, "Special nique (see Chapter 8, "Special

BRUSHES

You'll never look at a brush the same way again after you've begun painting on fabric. You'll collect brushes—good ones that you'll care for and cheap ones to use once. And you'll see other objects as brushes—sea sponges and shoe-polish applicators, for instance—even a turkey baster.

Michelle says that a brush is "like a relationship. A good one just feels right."

Unlike relationships, however, you'll have room in your life for every brush that strikes your fancy. Each one is going to work just a little differently and give you a slightly altered effect. Having a good collection helps keep your options open. And size does matter. You might want the same type of brush in several sizes—large for painting backgrounds and tiny for perfecting star points.

You'll find foam brushes indispensable in fabric painting. You'll also use paint rollers, both plain and textured; chamois cloth; and all the mitts marketed for faux-finish applications. Don't limit yourself to art-supply counters; shop at the hardware store as well.

Don't skimp on these important tools, and don't hesitate to invest in the good ones. A good collection of brushes will include: cheap ones from the hardware store ranging from a

½ inch to 3 inches in width (good for backgrounds and painting over wax); foam brushes in a range of widths; artist's brushes with synthetic or natural bristles; and stencil brushes with stiff bristles in varied sizes. Michelle finds these brushes indispensable: ¼-inch flat, ½-inch flat, and

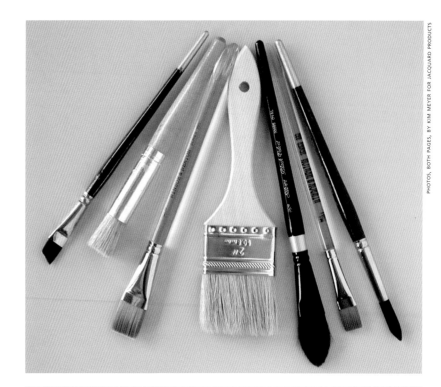

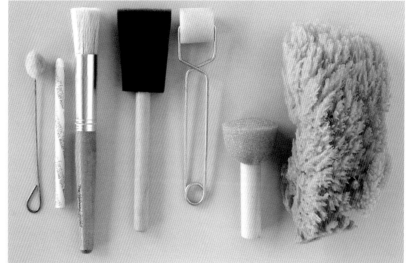

Above: You can't have too many brushes. Some you'll toss out after one use; others you'll treasure and collect.

Below: When is a brush not a brush? When it's a shoe-polish dauber, a wicking crayon, a chunk of foam (Spouncer), or a piece of sponge.

¾-inch flat; no. 12 round; and assorted bamboo brushes.

FABRIC STRETCHERS

A s with any other activity, fabric painting is more enjoyable with the right work area all set up. In addition to good ventilation and lighting and easy clean-up, you need efficient ways to hold fabric in place. A length of fabric isn't like a chair or a framed canvas. It won't hold still and be patient. It has its own wild and sneaky nature and has to be tamed in some way before you can begin to work your magic on it. You need some method to stretch it drum-taut, even if you are freehand-painting an irregular, improvised design.

A PADDED TABLE

M ichelle finds that her ideal surface for freehand painting, stamping, and stenciling is a padded table. If you decide that you agree, make sure it's the proper ergonomic height for you, usually 36 to 38 inches from the floor. Access from all four sides is preferable, though you can get by with one narrow end of the table against a wall, if necessary. For waxing, you'll want your fabric stretched, not pinned to the padded surface. We'll talk more about that later.

It isn't difficult to make a padded tabletop. Begin with a ½-inch- or ⅜-inch-thick sheet of plywood. Cover it with a piece of foam (like NU-Foam from Fairfield) or two layers of carpet padding or heavy industrial felt. Over this, place a piece of muslin or an old sheet large enough to wrap and tack (or staple) snugly around to the other side. You can devise a smaller version if you don't want to pad an entire table. Just use smaller pieces of foam, plywood, and muslin; you can set it on top of your regular wood surface.

Now it's a simple matter to stretch a piece of fabric; anchor it with T-pins (metal

A padded work table makes your life so easy. Muslin wraps around a layer of foam. Staple or tack in place.

pins shaped like a capital T), and hold it in place. Insert the T-pins at an angle with the point of the pin angling toward the center.

When you're just starting out, you can use the same principles to make a portable padded board any size you like.

In the absence of a proper padded table, use a common ironing board. Its contours make it easy to work on constructed garments and pillow covers, and the like. You can anchor the fabric with T-pins if necessary.

OTHER TOOLS FOR STRETCHING FABRIC

The padded surfaces Michelle recommends are excellent for stamping, stenciling, printing, and lots of other techniques. Wax resists call for stretchers—otherwise the wax will glue the fabric to the table. There are other occasions when you want the fabric to be stretched rather than tacked to a surface.

Sawhorses allow you to stretch just about any length of yardage, within reason. For fabrics up to 2½ yards long, the sawhorses alone will suffice; anything longer, and the fabric begins to get a little wobbly along the edges. For these lengths, attach strips of 1-inch molding or similar wooden pieces to the sawhorses with C-clamps (clamps with screws at the bottom) to make side stabilizers. You can then pin the sides of the fabric to these with push pins.

A freestanding quilting frame works just fine for a fabric-stretcher.

You can easily improvise other devices for stretching smaller pieces of fabric: embroidery hoops, needlepoint stretcher frames, and so forth. Picture frames work just fine; you can use an old drawer from a cabinet or a dresser, or lay fabric over the open end of a big box and anchor it snugly with an oversized rubber band (available at office-supply stores). When your piece of fabric is too small to fit the available frame, do not despair. Make extensions by sewing or pinning strips of fabric to the edge, then tack those to the frame, as shown in the photos. If you find you really enjoy silk painting and want to do it more efficiently, you might want to use claw hooks. The prongs are sharp and fine so they don't damage the fabric, and rubber bands make it easy to achieve the desired tension.

Speaking of improvisation, here's a revolutionary idea: You can stabilize the fabric by ironing it to the shiny, plasticized side of freezer paper!

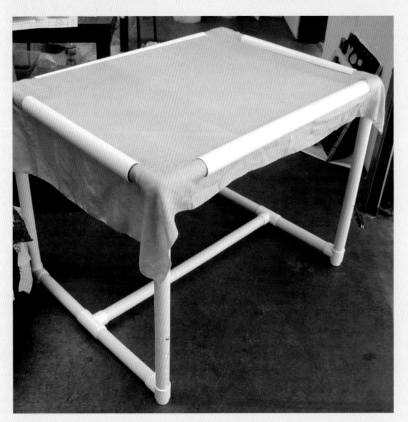

Left: *A PVC freestanding quilt frame is sturdy, portable, and lightweight. It does double duty as a silk-stretching device. And—if you want to quilt your project after you've painted it— just put it right back on the frame (from Prym Dritz).*

Below: *Silk stretched over a large cardboard box, anchored with a super-size rubber band.*

Silk is stretched on a wooden frame, ready to paint.

Small pieces of fabric can be stretched in an embroidery hoop.

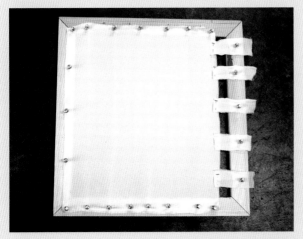

To extend a piece of fabric to fit the stretcher frame, sew or pin strips of fabric to it, then tack them to the frame.

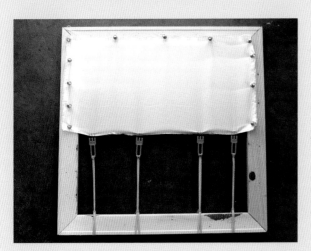

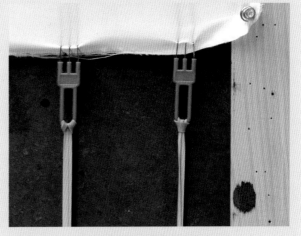

Designed especially for the purpose, claw hooks grab the fabric and stretch it easily to fit the frame.

DESIGN

Notice that this chapter comes after "Materials and Tools" and before "Freehand Painting." After *you collect your lovely natural-fiber fabrics, brushes, and paints, and* before *you dip that brush into the paint and stroke it onto the silk, you need to have some idea of what you want to do.*

Many of us believe, because of our experiences in art class in school, that we don't have any artistic talent—we suffer from fear of art. Upon analysis, however, that boils down to a simple fear of drawing. And drawing, while quite gratifying, is only one form of artistic expression. We know many professional artists who can't draw. It's not necessary. Forget your fear and approach the process of design with confidence.

SOURCES OF INSPIRATION

MAKING MARKS

You say you can't even draw a straight line? Fine. That's what rulers are for, you know. Wobbly, irregular lines look more interesting anyway. The same goes for perfect circles, perfectly spaced repeat motifs, perfect anything. You want perfect? Go buy some gingham! We're involved here with the custom-made, the handmade, the designer original, the one of a kind. We're going to paint fabric that would retail—if you could find it—for hundreds of dollars a yard. And to command that kind of price, the hand of the artist should be visible.

So remember, no whining from this point forward.

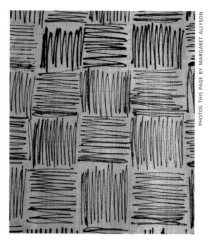

Above: *This design is really nothing more than marks on pineapple cloth.*

Below: *Notice how simple, yet effective these designs are. No drawing required—just making marks.*

There are opportunities for mistakes—but for each one of these, there is a brilliant design solution. Mistakes offer you a creative challenge. Michelle says that some of her best pieces evolve from a determination to overcome a problem. So while you may make mistakes, there are also some dependable preventative measures you can take. We'll tell you about those on a case-by-case basis.

FROM PHOTO TO FABRIC

Michelle considers her camera her "third eye." I'd go even further and call it a "backup memory." We both recommend carrying your camera around so much that it becomes as important as your daily planner and your keys.

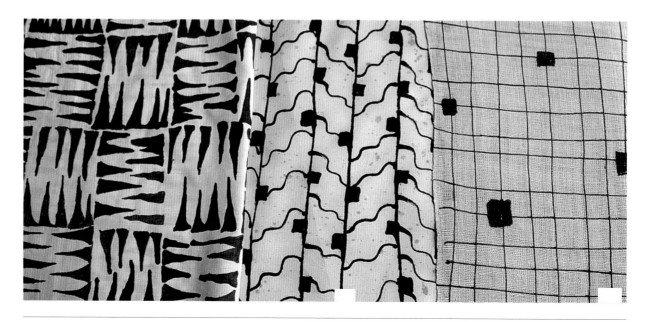

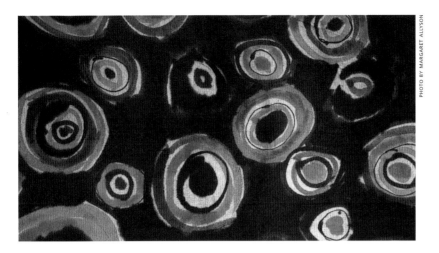

patterns, and color combina-
tions—even shadows—and
swears by her beloved Pentax.

MAKING THE MOST OF MAGAZINES

If you're like most people, you
subscribe to several maga-
zines. Instead of stacking them
after that first casual glance,
thinking you'll get back to them
later (which you never do),
make it a habit to tear out
pages as you go. (Michelle files
them in transparent sleeve pro-
tectors in a notebook; I just
stack them on a shelf.) These
pages might feature colors that
appeal to you—a photo of pur-
ple crocuses massed in a
wooden bowl with yellow pep-
pers recently joined my collec-
tion. Or, you might save
clothing shapes from fashion
magazines, elegant rooms from
Architectural Digest, or
photo essays about the desert.
These pages don't need much
organization; just look through
them randomly to remind your-
self of design possibilities or to
get inspiration for projects.

People lucky enough to have
friends around who share similar
interests will do well to share
magazines. Two or three artistic
souls can reduce a chunky mag-
azine to its barest bones, after
which you'll recycle, of course.
Using a color photocopier can
help to prevent disagreements.

This camera does not have
to be expensive. In fact, that
might be counterproductive
right at first: What if I drop it?
Or lose it? Make friends with
an inexpensive or old camera
with a built-in flash and a zoom
lens, one that's small enough
to fit in your purse. You won't
worry about it, and in the
meantime you'll be capturing
wrought-iron fences, flocks of
birds, and peaches piled high
at the farmer's market. After
you've become accustomed to
having a camera at hand, you
might want to upgrade. But
you might not.

The photos you take cap-
ture those moments you want
to remember. They transport
you back in time. You'll not
only have the line, shape, and
color that intrigued you, but
you'll remember the time of
day, the temperature, the breeze,
the fragrances.

Don't wait until you take a
trip—there are countless design
inspirations in domestic settings
as immediate as your own

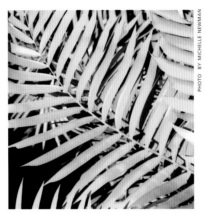

Top: *Raindrops splashing into puddles
might have inspired this strong design
of vaguely concentric circles.*

Above: *These palm leaves that Michelle
captured on film may show up in a
future design.*

backyard. Michelle even takes
her camera on dates. We've
been chastised more than once
for photographing people or
their surroundings, but those
are minor setbacks and do not
discourage us. For every scold-
ing, there have been a dozen
good ideas and occasionally
some new acquaintances.

Michelle uses her camera to
record composition, textures,

DOODLES AND DRAWINGS

Some psychologists claim they can tell a lot about you by whether you doodle straight lines or curves. You probably have a repertoire of lines that flow automatically from your pen or pencil while you're on hold with tech support. Maybe you produce rows of zigzags, pyramids of not-quite-perfect circles, stacked squares, or parallel waves.

Well, guess what? Those are just the kinds of simple, repetitive motifs that look like a million bucks when they are translated into fabric design.

Instead of throwing that junk-mail envelope away once you've covered it with lightning bolts, save it in your design folder (or booklet or box). One will do; after that, you can discard your lightning bolts until you come up with a variation on that theme.

SKETCHBOOK

There will be times when you can't use your camera—in museums or theaters, for instance. That's when you'll be glad to have a sketchbook handy. Michelle favors small ones that tuck into her handbag. You'll probably be happiest with unlined pages and a

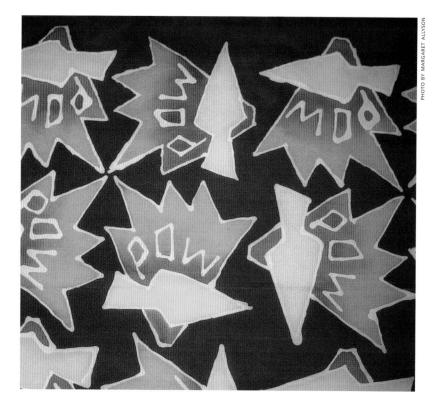

Above: *Keep those odd scribbles: This powerful design, incorporating text, features a simple repeating shape.*

Right: *Are they Easter eggs? Flying saucers? Michelle noted the essence of whatever inspired these floating shapes in her sketchbook.*

Opposite: *A repeating broad stroke on indigo velvet. Just enough variation in the pattern on rich texture makes a perfect garment.*

spiral binding. As with your camera, don't treat your sketchbook like some holy icon—use it frequently, even for doodles. When it's full, date it, label it, and put it on a shelf before you start another.

What's your favorite writing and drawing implement? This isn't a frivolous question to many of us. If you delight in a sharp no. 2 pencil or a black razor-point marker, make sure to carry a couple of those around with you. You'll be able to capture line or mass with a ballpoint pen, but you'll be more inclined to keep drawing if you really like the instrument.

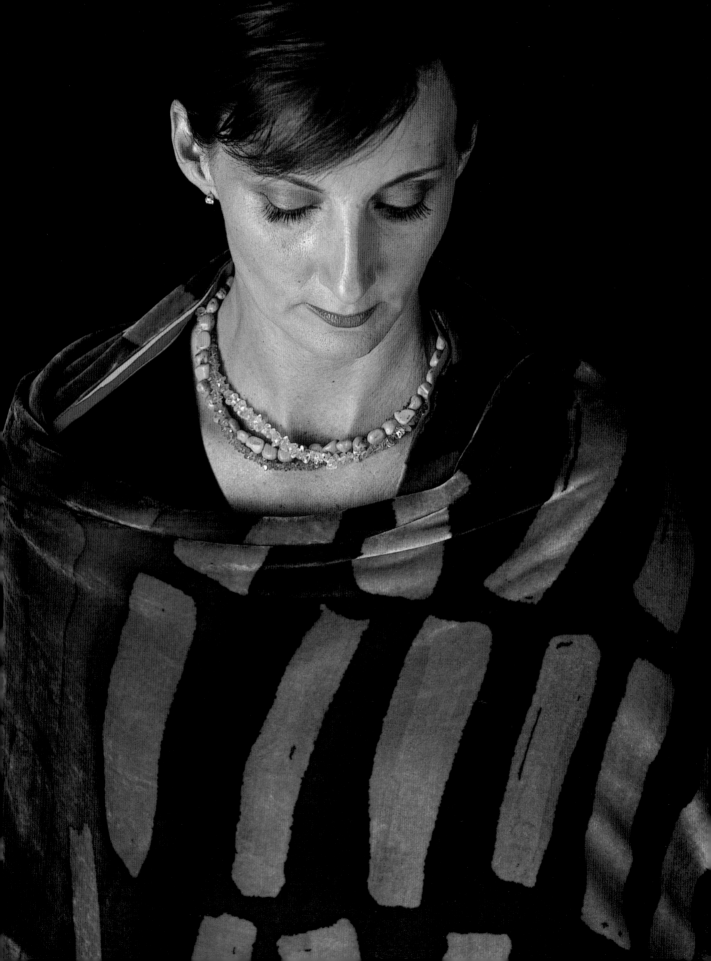

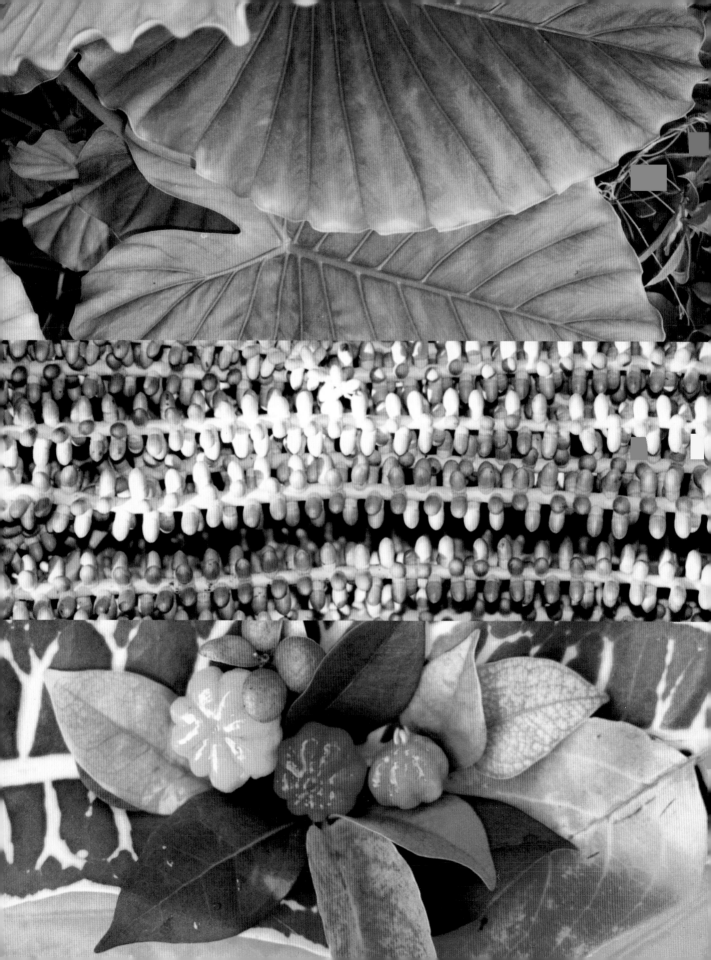

TRAVEL, ARCHITECTURE, NATURE

Looking through Michelle's snapshots and sketchbooks, I see surfboards at Waikiki Beach, tropical foliage from several continents, art deco buildings in New York and South Beach, flowers from everywhere, and more visions and versions of the ocean than you can imagine. "I keep painting blues," she explains. She also collects images of Asian design influences, tribal motifs from Egypt and Morocco, and hands decorated with mehndi (henna) designs.

Michelle travels more than most people. Maybe you won't find yourself at a Blackfoot powwow in Canada or a remote village on the Nile—in real life, that is. But you have access to *National Geographic* and a public library and museums. Trees in the backyard. The old courthouse. It's all a matter of turning your attention to the abundant elements of design that surround you no matter where you live. And in so doing, you refine your own style. You discover what fires you up, what colors and motifs resonate with you, what time periods or geographical areas make you comfortable. You accumulate a personal reserve

of style—ever so handy when you're painting, carving stamps, or dribbling hot wax onto velvet.

We all have downtimes, creative blocks, or periods of stagnation. Those are times when we need a jump start and when the notebooks come to our rescue.

"It's important to look at things from a different perspective and angle," says Michelle.

"For example, I think of patch-work fields and meandering rivers seen from an airplane or the spores of a plant magnified by an electron microscope."

Opposite: Michelle's casual snapshots of tropical vegetation are beautiful in their own right and serve as reminders of possibilities for patterns.

Below: An art deco architectural detail inspired Michelle's design for this coat, made for the Fairfield invitational fashion show.

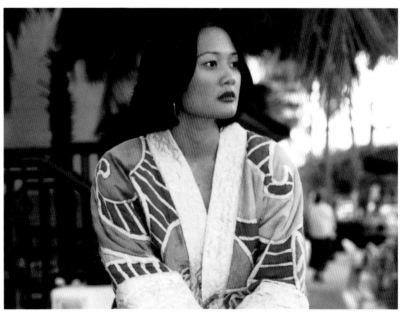

ELEMENTS AND PRINCIPLES

You can find complete discussions of the elements and principles of design in lots of art instruction books, so let's talk here about what really concerns the textile artist.

The most important *elements* relevant to fabric painting are line, color, and texture. The *principles* organize the way you work with those elements.

ELEMENTS

We've already talked about *lines* as design elements. They're one of the easiest, most basic ways to embellish fabric (or any other surface, for that matter). As you look at the photographs in this book, you'll see Michelle's varied use of lines in her designs—hers are

often parallel, wavy, squiggly, meandering, or broken.

Some of the techniques Michelle uses, such as the Fortuny-pleated scarves, add or

Opposite: *Merci, Matisse—an organza jacket and pleated scarf show the influence of the great Impressionist painter.*

Below: *Michelle often looks to nature for design sources. The leaf motif can be varied almost infinitely.*

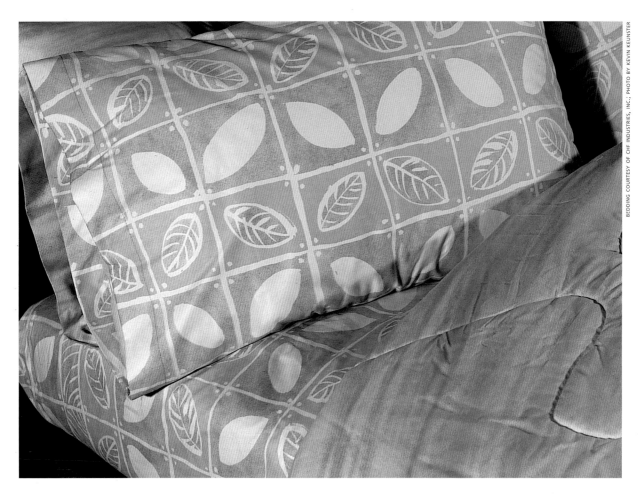

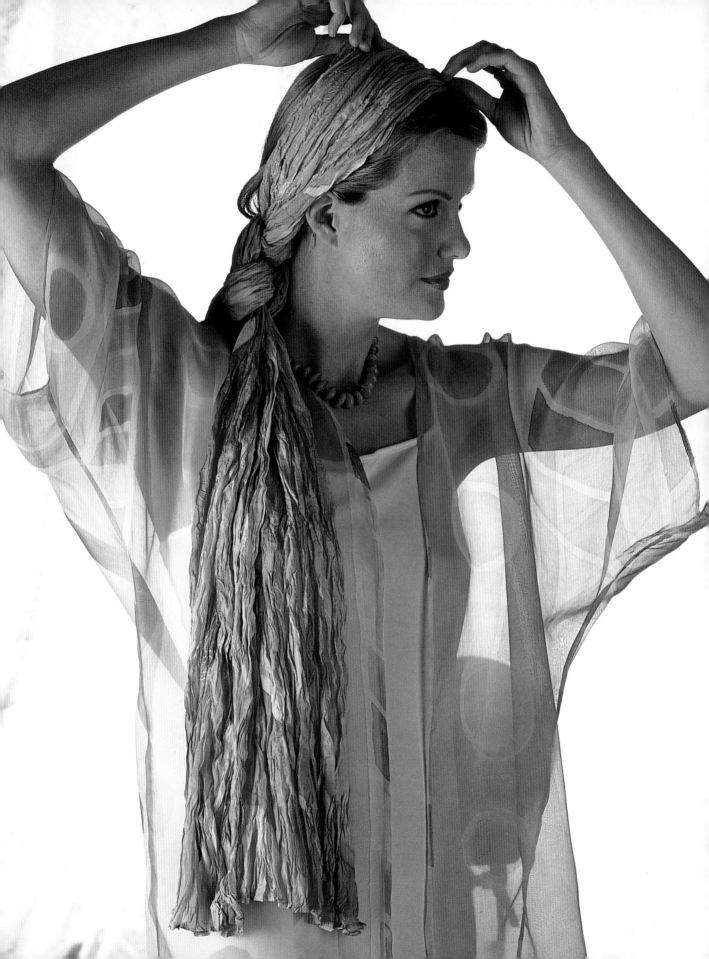

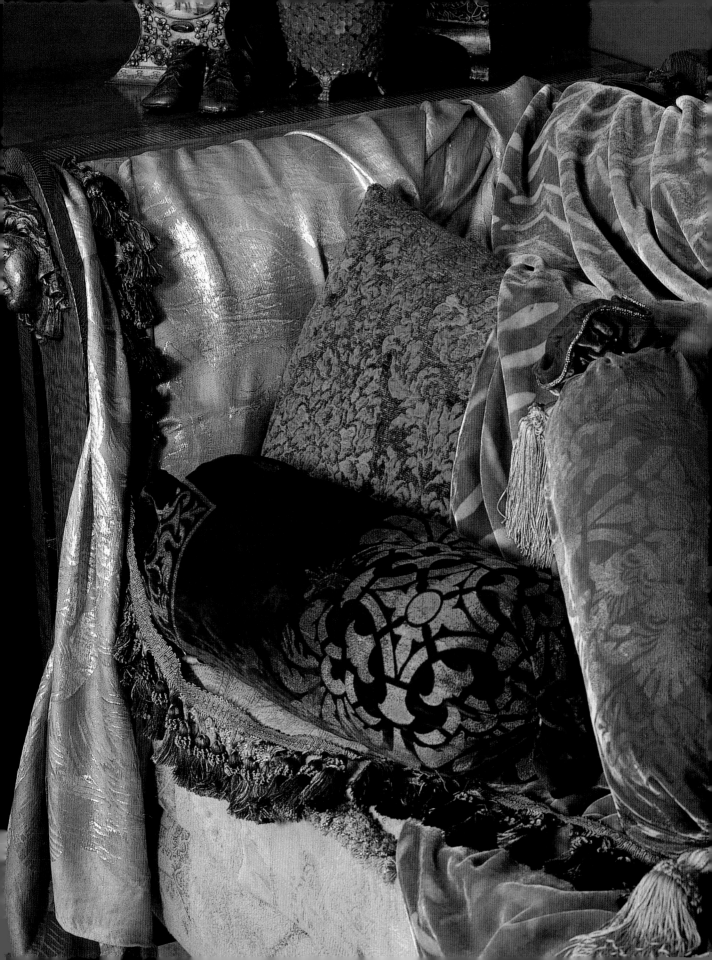

alter *texture*. However, most of the effects we achieve with texture work with the qualities inherent in the fabric itself. A rough, primitive weave, for instance, will not lend itself to intricate, detailed designs because they'll get lost in the texture. You'll soon develop a sense of this for yourself as you delight in velvet's tactile thrill, the crunch of taffeta, the crisp freshness of silk organza. You won't make more than a couple of mistakes because the connections are pretty self evident.

COLOR

So now we come to *color*. Color is quite personal and intimate. It evokes passionate responses: "I hate yellow!" or, "Pink! More pink!" or, "I don't care—I need *another* black T-shirt!" (Notice all the exclamation points.) We really, really care about color.

And yet, even though it works so well in nature, using every single color you can think of or create in one composition seldom results in a good piece of art. As we get into talking about the organizing principles, we'll spend

Opposite: Just try to imagine this grouping in another fabric. Although the colors and designs are luscious, the overall statement is about texture. Motifs on pillows are silkscreened; the velvet throw is handpainted.

more time with color than with the other elements.

Michelle often reaches for deep, opulent tones—rich hues that vibrate against or merge fluidly into the others. Many of us share this love for jewel-like colors. When she began designing for home-dec manufacturers, though, she had to depart from her personal preferences. While people feel quite comfortable wearing a vivid turquoise blouse or a deep plum shawl, they suddenly get timid about buying curtains and duvet covers. (We will refrain here from our usual rant about this and mention quite calmly that Michelle's home is black and gold and full of leopard spots, while mine is black, hot pink, orange, and turquoise.)

Michelle, however, had to get out of her comfort zone and design in some neutral colors. This didn't seem to cause any problems, and she quickly produced dozens of lovely, interesting lengths of fabric that proved enormously popular. She calls them the "Neutral Zone." The point is that good design is good design. Once you've played about with this for awhile, a drastic shift in your colorways won't cause a ripple on the stream of your enjoyment. If your mom loves your designs and wants a beige pillow, you'll be able to create it for her and have a good time doing so.

See what we mean? We can talk about color for hours.

COLOR TIPS

Most people don't use a color wheel, but it's a handy tool. On one side, you'll see the warm colors (red, orange, yellow), on the other side, the cool ones (blue, green, and purple). Warm colors evoke feelings of fire, the sun—very warm things indeed. Michelle thinks of cool colors as "mermaid" colors, but they can also conjure up visions of clouds, water, grass, or sky.

A color scheme composed of three or four adjacent neighbors on the wheel—analogous colors—is always safe. In fact, you won't ever go wrong using all cool colors or all warm ones. Don't think that a monochromatic color scheme will be boring. It can be very rich and textured.

It's when you combine hues from "other neighborhoods"—across the wheel—that things can get a little dicey. Adding a complementary color from the other side can turn your color into optical mud, a neutral. As you work through this (for there are no hard-and-fast rules), remember that you can use this fact to your advantage. Orange too bright? Don't tame it with black. Reach for its complement—in this case, blue—and add the tiniest drop to tone down an aggressive orange. This works all around the wheel. Be cautious with dark colors, adding them in small increments to lighter ones.

PRINCIPLES

The organizing principles, as we said, are ways to handle the elements we've just outlined. We'll run through the principles point by point, trying to avoid further sermonettes about color.

Repetition is a major factor in Michelle's design style. She repeats lines, motifs, blocks of color. In one way it's a bold approach; when she encountered the craft world, fabric painting was almost totally realistic and almost entirely limited to plants and animals—lilies, pineapples, and parrots on silk scarves; roses and bunnies on cotton sweatshirts. In another way, though, repetition is a can't-miss strategy. From rows of handprints on the walls of the caves at Lascaux to Andy Warhol's multiple Marilyns, repetition is a sure-fire way to ensure that a design has a unified composition. It provides a sense of cohesion and holds a design together. As poet, essayist, and naturalist Diane Ackerman says, "Once is an instance. Twice maybe an accident. But three times or more is a pattern."

Variety keeps things from being too unified, too safe, or too predictable. The hand of the artist often takes care of this in the art of fabric painting. Because it's difficult to achieve "perfection" without precise

Opposite: *This bedding ensemble, inspired by a leaf shape, shows the principles of rhythm, proportion, and economy.*

Below: *You'll see repetition, variety, balance, rhythm, and economy at work in the composition of these pillows. Note especially the subdued color themes.*

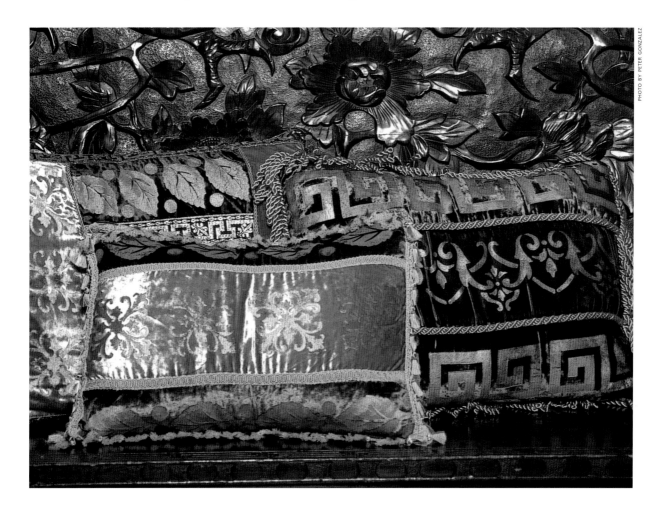

measuring and preplotting (plus, it's no fun), variety occurs automatically. In other words, don't worry about it. Even if you stamp black lines on a white background in parallel rows, you'll wind up with a distinctive custom piece of fabric. You can't escape variety. If you want to, as we said, go buy some gingham.

Rhythm is produced by contrast like that between empty space and parallel rows of lines in a design. There are countless rhythms in visual arts, just like in music. This rhythm can be very *metric* and mechanical like a Sousa march; *flowing* like a Schubert sonata; *swirling* like Ravel's *Bolero*; or *climactic* like Wagner's "Ring" operas. Rhythm involves placing elements in a way that establishes balance and creates movement.

Balance is important to the fabric painter at two different stages: first, when planning the design, and second, when constructing the finished item, unless it's a pillow or shower curtain or something equally flat. For wearable items, consider where such design elements as dramatic concentric circles will fall on the garment when it is actually worn.

Balance can be tricky. Symmetrical designs are instantly balanced but can get a little boring. So you experiment. Like color, balance is intuitive. Luckily, fabric painting is an art

ELEMENTS OF DESIGN

form
space
line
texture
light
color
time

PRINCIPLES OF DESIGN

repetition
variety
rhythm
balance
emphasis
economy
proportion

form that allows you to keep adding to, subtracting from, and otherwise altering your work. If you want to outline some blue squares with thin yellow lines for aesthetic balance, you can do so at any time. (See "Layering" in Chapter 8.)

Emphasis means giving a particular area or characteristic prominence. To create such a focal point, you emphasize something to give it added importance. Again, this is something you can develop; you can meditate on a very simple repeat design after it's supposedly finished and then decide to emphasize certain motifs within it. Layering also gives you flexibility; you can keep coming back to a piece until you are satisfied.

Economy involves removing what is not necessary. This principle is most evident in home decor right now. Rather than doilies, throw rugs, and a wall full of pictures, we're seeing stripped-down, industrial, Zen-like minimalism. It's peaceful and serene (though one wonders where people in such homes keep the catbox). "Stanley Marcus [the late founder of Neiman Marcus] taught me about selective editing," Michelle says. "He applied it to the design of retail spaces, but it works for fabric design, too. Pare away the nonessentials so that you can focus on the most important things." In fabric painting, economy can mean limiting your color palette or saving that fourth row of motifs for your next project. If it looks busy, it does not embody the principle of economy—which doesn't mean it's bad. Too much can be exciting, but can also lead to chaos. Just make sure that's the look you want.

Proportion is as subjective as color and balance. Classical Greek artists developed proportion into an exact science, but anything exact can provoke big yawns. If it feels right, it's probably in proportion. Let your intuition guide you.

Even though you see many types of patterning in these two fabrics, economy in color keeps them from being too busy. The note of orange in the background fabric provides variety.

LAYING OUT A DESIGN

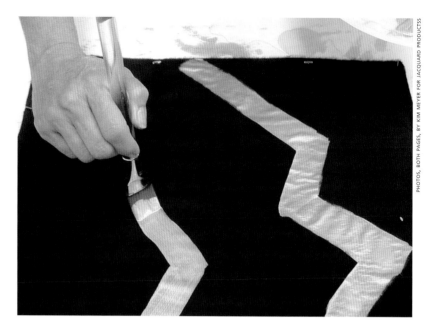

Now you have a head full of ideas, and you're ready to get started. You've probably saved pages of your own scribbled designs and torn out lots of high-gloss pages from magazines. It's time to decide how much preplanning you need.

Many beginners plan too much. They measure and mark and fret. This is supposed to be fun. If you delight in being precise and obsessive, go right ahead, but personally, we think precision is highly overrated and would rather see you improvise. But that's up to you.

Depending on what you're going to use your hand-painted fabric for, we advise that you do some preliminary thinking. If you're planning something to wear, consider proportion and placement. You don't want to lose a major motif in a side seam, for instance. However, simple repeat geometrics are going to work for just about anything, including wearables, pillows, and tablecoverings.

Michelle lays out many of her designs in a way that guarantees coherent composition and yet leaves room for lots of improvisation along the way.

Let's see just how easy this can be as we follow Michelle through three steps she often uses in freehand painting.

1. "Create big zones," she says, as she dips a ¾-inch flat brush into gold metallic paint. "This is like a map, and I'm painting in the major highways." She quickly paints large, thick, jagged lines onto the black charmeuse.

IN PRAISE OF PURITY

There's absolutely nothing wrong, of course, with plain, undecorated fabric. Who could quarrel with yards of ivory silk, satin, or pure-white charmeuse? These examples do conjure up images of brides, but seriously—don't think that you must color, embellish, pattern, and texturize fabrics just because you know how. Remember that the eye requires resting places. Juxtapose your magnificent motifs and designs with empty fields of solid colors, including neutrals.

2. Next she chooses a ½-inch flat brush and switches to copper paint. She paints a wave pattern between the wide gold lines. (Whether you let the paint dry between colors and steps is up to you. When you're doing a hard-edged design like this, you want it to be reasonably neat and clean. Some of us have the coordination to achieve this while working around wet paint; some of us don't. Michelle continues painting without waiting.) Although Michelle doesn't continue her analogy, now that we have the idea, we can imagine that the copper lines are like main streets meandering beneath the gold highways.

3. As each zone gets smaller, she uses a smaller brush. Finally, with a ¼-inch flat brush and silver metallic, she fills in the open spaces with circles. These could be

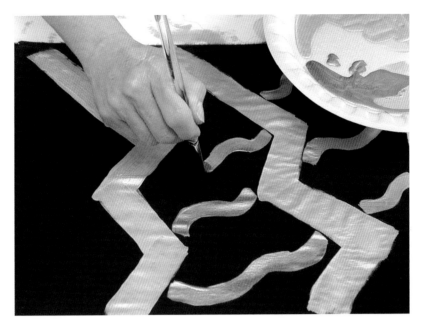

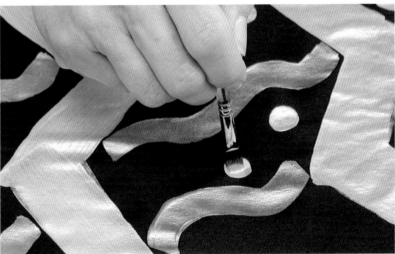

neighborhood lanes, if we're still imagining.

Three simple, unstudied motifs—jagged lines, wavy lines, and circles—combine to make a timeless pattern that could just as easily embellish a clay wall in an aboriginal village as this black silk scarf. In fact, the design combines influences from Australia and South Beach.

We just talked about repetition as one of the principles of design. Because so much of Michelle's work is based upon textures, geometric shapes, ethnic motifs, and inspiration from nature, repetition is especially important. Another reason repetition plays a major role in Michelle's work is that her style of painting is abstract, not realistic. If you want to paint realistic-looking trees, one single tree can serve as a design element because of its inherent pattern and design. The same would be true of other recognizable forms. But if you're creating your own shapes, a repeating pattern gives your work coherence.

The design we just explored is coherent and pleasing largely because of the repetition of line, shape, and color. What if the wavy copper lines had alternated with wide, straight lines? Or copper were mixed with pewter? What if the little silver circles were multicolored instead? Or of varying sizes? The impact of the design might have been diminished. In other cases, variety and economy, rather than repetition, make for effective design. (Now you're beginning to see why fabric painting is so seductive— exploring variations on a design can keep you up late at night.)

Just as a musical composition repeats themes to give it an overall structure and make it memorable, a visual design is strengthened by repeated motifs and shapes.

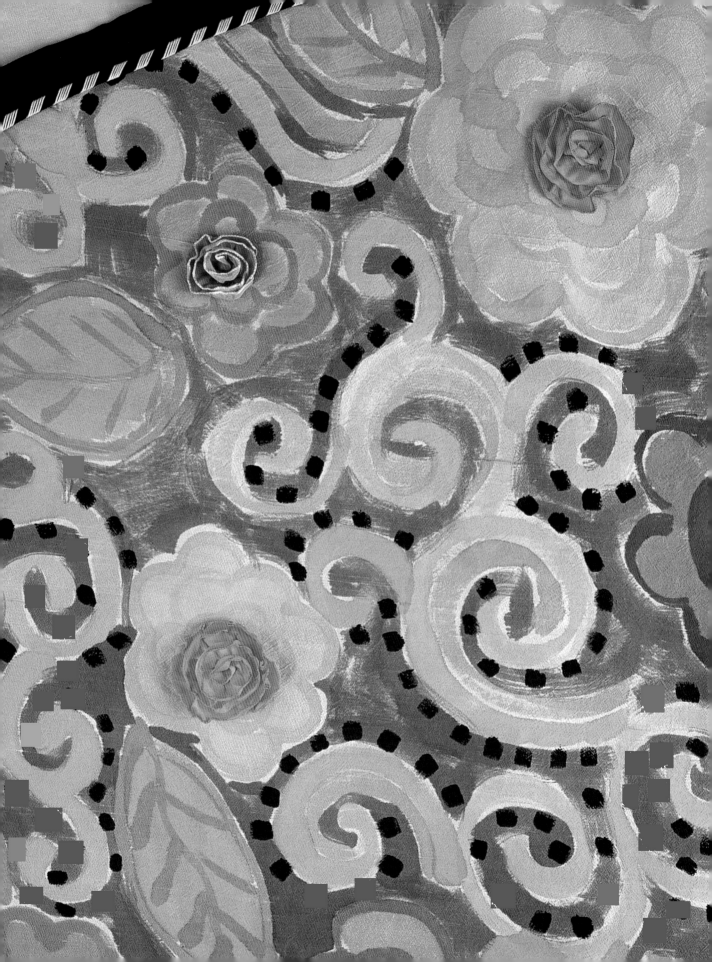

FREEHAND PAINTING

Now don't hyperventilate! There's nothing intimidating about freehand painting. When you remember that the repetition of any motif makes a legitimate pattern, you'll realize that there is nothing to fear. Freehand painting is about making marks with paint.

Why measure stripes or trace a simple leaf shape when it's more fun to jump right in and really be free with the paint? Artisans from around the world (and throughout the ages) have approached their creations in this way. One-of-a-kind, handmade pieces have much more value and drama than machine-made, mass-produced items. You want the hand of the artist to be an important part of your creation.

WET FABRIC

ere's a technique that delivers instant gratification. When you paint on wet fabric, a method known as "wet on wet," wonderful things happen. Your choices and intentions are joined by the element of chance. Synchronicity and serendipity become your partners. Unpredictable effects appear before your eyes. Colors sink into the fabric in unexpected, variable ways. Shades and tints create themselves, and hues blend in complex mixtures you might not have imagined. Freehand painting is a lot like watercolor painting—it's very forgiving and user-friendly.

Stretch your fabric while it's dry, then spray it. Or, if you're going to wash the fabric you're using, you can take it right out

Below: *Painting wet on wet is an exciting way to apply color to fabric. Monochromatic or rainbow ombré effects are easy to achieve. Color flows are fluid and graceful. Sponge-painting also works well on wet silk. As she works from lighter to darker tones, Michelle will eventually cover the entire surface of this white background.*

of the washing machine and begin painting. Dip a wide brush (1½-inch or so) into paint

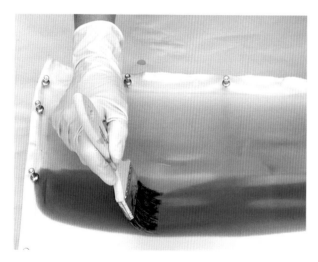
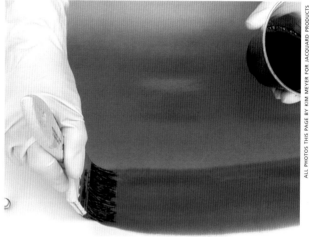
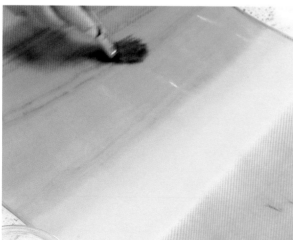
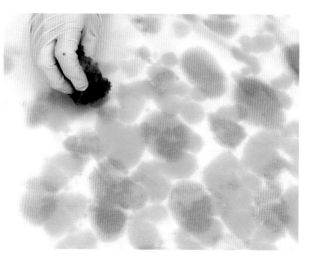

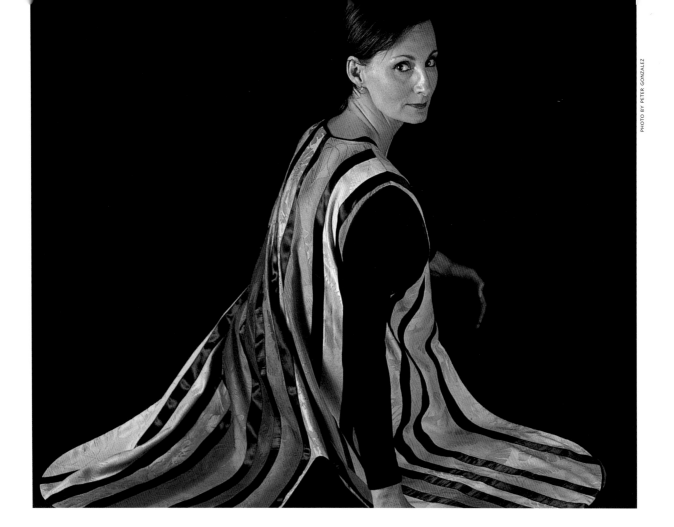

PHOTO BY PETER GONZALEZ

or dye and stroke it across the wet fabric. You'll see the strongest color in the center of the stripe, then it will fade or bleed out toward the edges. You can use this to your advantage, to blend and overlap colors or to produce gradations and ombré effects. To get a sense of the range of color effects it's possible to create, think of a watercolor or one of Monet's waterlily paintings.

Of course, you are not limited to a single hue. As long as the mix that results from adjacent colors is pleasing, you can paint a multicolored ombré—even a rainbow.

How opaque the overlapping areas are depends on the paint or dye you are using. Dye-Na-Flow, diluted with equal parts water, was used for the rainbow scarf. It produces a translucent wash effect.

You're not limited to brushes when painting wet on wet. Sponging works very well, and so does spraying. Both of these will result in an interesting, mottled, multidimensional look that is comparable to the difference between a flat painted wall and a color-glazed or rag-rolled surface. Quilters covet this kind of fabric because it combines the

The rainbow ombré of this technicolor tunic was painted on wet fabric. The black ribbons simultaneously obscure and draw attention to the places where the colors blend.

qualities of solids and prints. It can attract the eye and stimulate the mind. A simple sponged or sprayed background can become an ideal "base coat" upon which you can layer other techniques. Of course, you can sponge on dry fabric, too.

For another example of this sort of painting, see "faux airbrush" in Chapter 8, "Special Effects."

DRY FABRIC

When you paint on dry fabric, a method called "wet on dry," you have more control over your paint or dye. Choose this method when you want clear, rich, more intense color. Your paint or dye won't bleed as much, but colors will still run somewhat unless you use some type of resist or the paint or dye is thick. Painting wet on dry is much more predictable; it produces a completely different look than painting wet on wet.

The effect you get depends on whether you're using paint or dye, whether it's full-strength, diluted, or thickened, and what kind of silk or other fabric you are painting on.

Michelle took the rainbow gradation scarf (painted on wet silk) and, after that color wash had dried, used full-strength Dye-Na-Flow and overpainted some motifs for accents—in other words, she made marks.

When you're working with acrylic paints on different fabrics, experiment with thinning the paints with water or textile medium until you get the right consistency. If the paint is too thick, the paint sits on the surface and dries hard. If the paint is too thin, the colors may not be bold enough.

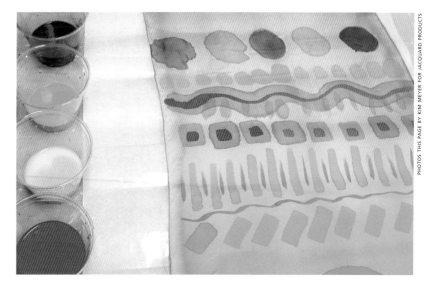

Above: *Most of the marks are tone on tone, but big green circles enliven the orange area.*

Right: *Long, curved lines streak across the silk.*

Right below: *Further curves cross and echo the pattern.*

Let's look at a few projects that were painted freehand whose designs range from mere marks to some big, over-the-top floral motifs.

SIMPLE STROKES

If you select a fabric in a strong, vibrant color, your painting will have maximum impact with just a few simple

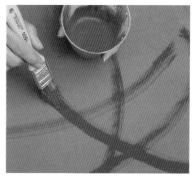

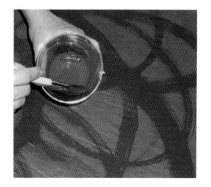

strokes of another bold color. Michelle used this principle to paint this orange silk piece

whose freeform composition reminds me of the paintings of the modern master Jackson Pollock.

To make this piece, Michelle applies spontaneous swirls of undiluted red Dye-Na-Flow to orange silk. She works quickly, using a flat, inch-wide brush. Because all the lines are large curves done in a single color, the design is easy to execute. Some areas can be sparse, while others can be dense.

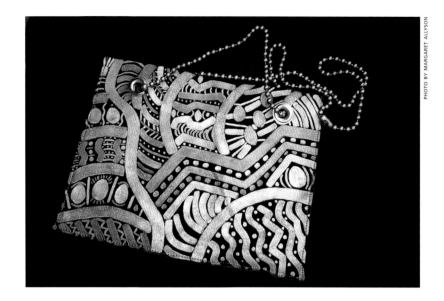

WORKING IN THE ZONES

In Chapter 2, we showed you how Michelle creates large "zones" of pattern with metallic paint, then works into smaller areas with progressively smaller brushes to create an overall design. This is another can't-miss method of freehand painting that produces a rhythmic, organized look with very little advance planning.

For the example featured above, Michelle began by establishing the zones on this black suede handbag. The wide gold wavy line on the left created the first design area in one stroke. The gold zigzags or perhaps the three swooping, silver curves might have come next. Middle-sized motifs followed, then the tiny accent dots and the smallest lines. One thing is certain: Michelle didn't waste

time worrying about what to do next, and you shouldn't, either. When you work this way, you're going to get a good coherent design.

Enlarge your perspective. Imagine doing the same thing on a grander scale. The quilted piece pictured below is big enough to be a bed covering or

Above: A purchased black suede bag, handpainted in geometric "zones."

Below: This spontaneous design has ancient Egyptian and art deco motifs.

a dramatic wallhanging. Its size and dramatic design make it a major statement no matter how it's used.

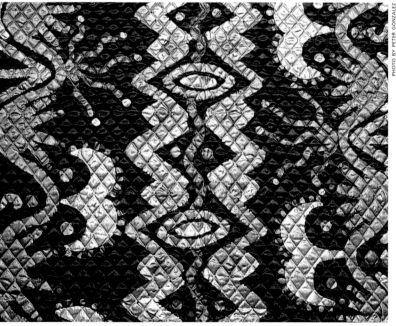

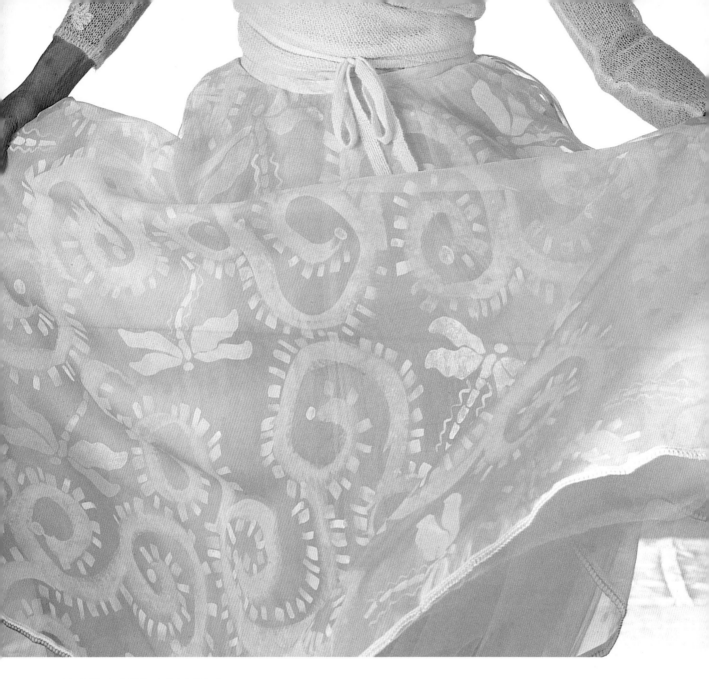

MONOCHROMATIC

Another way to get started with freehand painting is to work tone-on-tone, or mono-chromatically. Some of Michelle's signature pieces use this technique. You *could* establish zones as Michelle did for her metallic designs, but that's not really necessary in monochromatic compositions.

Like those zone paintings, however, in monochromatic pieces you should work from large motifs to small, and grad-ually decrease the size of your brush. Then your largest motifs aren't crowded, and you can add progressively smaller designs until you are satisfied.

White silk organza skirt, stamped and freehand-painted in white and ivory.

The fabulous fairytale creation in the photo above is almost entirely handpainted, although the dragonfly motif was stamped. The swirls were painted first, followed by the lines and dots.

THE COLORING-BOOK METHOD

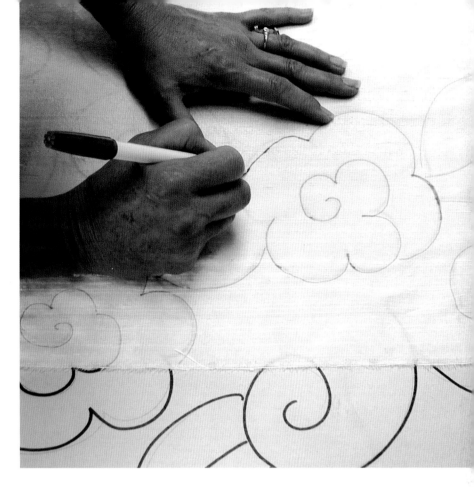

The coloring-book method isn't as loose and spontaneous as freehand painting, but it's as easy as coloring within the lines. Choose this technique when you want to pre-establish your motifs. There's plenty of room for improvisation when you get into the "coloring" part.

Begin by drawing, tracing, or photocopying a design to the desired size on paper. Go over the major lines (not the details) with a black marker. You can often see through light-colored or lightweight fabric, and it's easy to lay the fabric over the paper and trace the design with a wash-out or fade-away marker or pencil (find at fabric stores). For thicker fabrics, you'll need to use a light table to make the design readable through the fabric. (It's easy to improvise a light table. Put a lamp underneath a glass-topped coffee table, or beneath

Above: *Trace the design directly onto your fabric.*

Right: *Lay tracing paper over the design and go over the lines with a ballpoint pen.*

Below left: *Now trace over the design onto the dark-colored fabric.* Below middle: *Lift the tracing paper to check the transfer.* Below right: *Paint over the white lines on the dark fabric.*

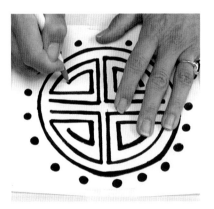
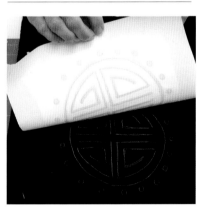
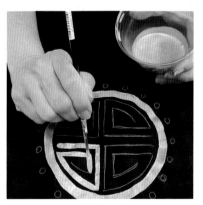

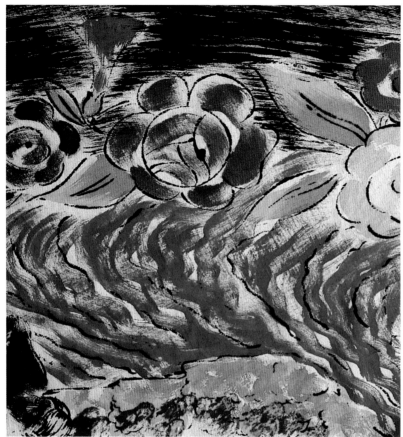

Hold one end of the paper down and lift the other end to check the impression. You may need to repeat the previous step. The motif appears in white on the dark fabric. Now it's a simple matter to paint over the transferred image.

SUMMING UP

Freehand painting is well within anyone's reach; don't be timid about applying paint on wet fabric for a watercolor effect, on dry fabric with zones, coloring in a traced design, or using monochromatic compositions.

Left: *A vintage skirt inspired Michelle's "Coochie Frida" series, named after Frida Kahlo.*

Opposite: *Coloring-book painting combines pre-planned designs and improvisational technique.*

a piece of plate glass placed over a sturdy platform. Or tape your design to a window and hold the fabric over it.)

When you are working with black or other dark-colored fabrics, there are other ways to transfer designs. Lay white transfer paper, coated side down, over your fabric. Lay the design you want to transfer over the transfer paper. It can be traced or photocopied onto plain paper. Go over the design with a ballpoint pen or a stylus.

Right: *Michelle traced the butterfly cartouches onto white douppioni silk and outlined the design areas with black resist. She painted in those areas with Dye-Na-Flow. After painting the background yellow and letting it dry, she added the green swirl and small strokes of black acrylic paint.*

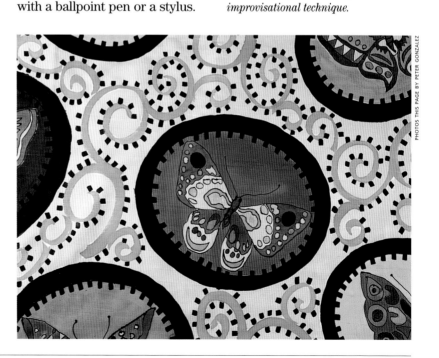

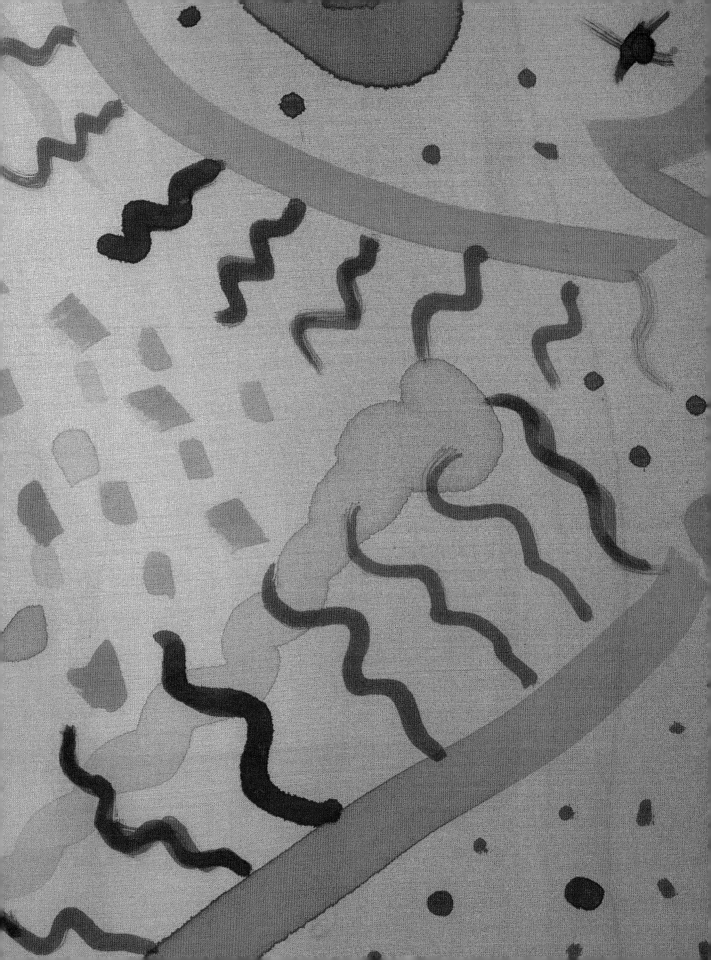

CHAPTER 4

DYEING

U nlike paints, dyes form a molecular bond with the fibers of a fabric. This means that no change in texture, no tactile difference, will be apparent. For this reason, choose dyes over paints when you want the fabric to remain soft and drapable, for example if you're making a scarf that will be worn next to your skin.

Dyeing can be a very complicated procedure involving auxiliary chemicals, balance scales, and split-second timing. We salute the technicians who work in this manner and admit freely that we do not approach the craft in that way at all. Michelle gets good results from her simplified techniques: gorgeous colors that neither wash out nor fade away. You may go on to explore more precise dyeing methods and refine your work in countless other ways. For now, here are the basics about the subject.

DYEING METHODS

IMMERSION

The easiest way to dye a fabric is to immerse it into the dye solution. Immersion dyeing can result in a smooth, overall, even field of color. Although there are eight billion colors of commercially dyed fabrics, you can shop for hours without finding the color of your dreams. So immersion dyeing, although it is almost too simple to mention, is a valuable method for achieving just the color you want. It's important to follow the dye manufacturer's directions. You can also overdye commercially dyed fabrics, but it takes more than one washing to remove sizing or other surface treatments. Overall immersion or scrunch-dyeing also works on natural-fiber commercial fabrics.

SCRUNCH-DYEING

Scrunching is another method that demonstrates the beauty of imperfections and irregularities. Instead of careful immersion, which gives the fabric an even color field, go in the opposite direction. First, scrunch up (by crumpling, wadding, folding, twisting, or knotting) the fabric, then stuff it into something to keep it compressed. Next, immerse the whole package, following the instructions for whatever dye you're using. This will create an intriguing mottled effect (a look that's immensely popular with quilters because it adds surface detail and a textured look). We've seen some gorgeous printed cottons that quilters have overdyed using the

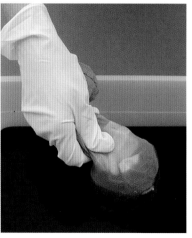

scrunch-dye method to produce effects in the fabric that would otherwise be unobtainable.

One easy way to scrunch-dye is to crumple your fabric and stuff it into a knee-high stocking or the leg cut from a pair of pantyhose. These make ideal containers because they're porous and stretchy. Whether you wet the fabric before scrunching it, wet it after it's packed into the stocking, or decide not to wet it at all is entirely up to you.

Wearing rubber gloves, immerse the crumpled fabric into a dye bath. Follow the dye manufacturer's instructions as to water temperature, length of immersion, and so on.

The finished fabric is beautiful as is, but you can also use it later as a base for layering: overpainting, printing, or stamping.

You'll see several examples of scrunch-dyeing in this book. For a subtle, moody effect, see the photos of work in progress on page 116.

Above left: *Scrunch up the fabric, wet or dry, and stuff it into a knee-high stocking or a leg cut from old pantyhose.*

Below left: *Immerse the crumpled fabric into the dye.*

PHOTOS BY KIM MEYER FOR JACQUARD PRODUCTS

WORKING WITH THICKENED DYES

When you want to use dyes as paints—that is to say, when you want to color particular parts of a fabric and you'd like one area to be red and an adjacent area to be pink—you have the option of working with thickened dyes on dry fabric. In the photo (above, right), Michelle is painting a simple repeat motif with thickened dye. Notice how the dye stays exactly where she wants it and does not bleed. Yet after the steaming process (see p. 94) or the first washing, there is no change in the hand of the fabric, meaning that the fabric does not feel stiff. In this way, for certain applications, thickened dye combines the best features of dyes and paints. It's an easy and manageable medium. By using a natural-bristle brush, you can leave brush marks for a painterly effect that adds texture and reveals the hand of the artist.

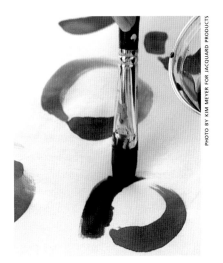

PHOTO BY KIM MEYER FOR JACQUARD PRODUCTS

There are many dye thickeners. Sodium alginate, a product derived from seaweed, is popular with many professional fiber artists. Superclear, a natural liquid gum (find at art supply stores) is easier to use. Add a little of the product to your dye or paint solution, and it's ready to go. Another means to achieving a similar result is to apply a solution to the fabric that inhibits a liquid dye's natural

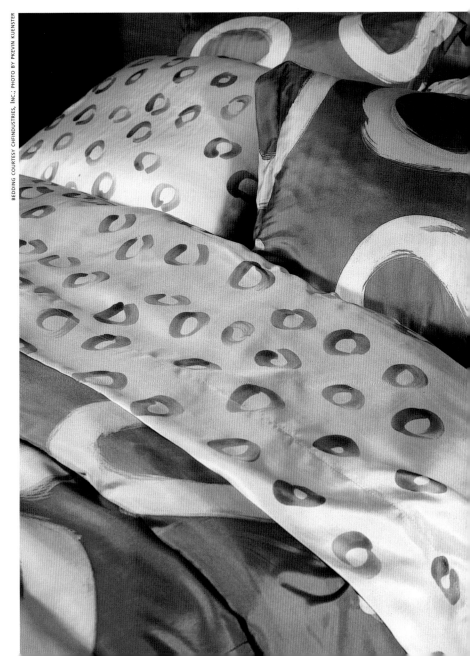

BEDDING COURTESY CHFINDUSTRIES, INC.; PHOTO BY PKEVIN KUENSTER

Above: *Using thickened dyes gives you more control over your design. Here, Michelle is painting her "broken bagel" motif onto white silk.*

Below: *Michelle painted the "broken bagel" design on the sheets for this bedding ensemble. Completed circles were used on the duvet and pillow shams.*

 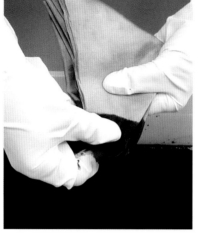 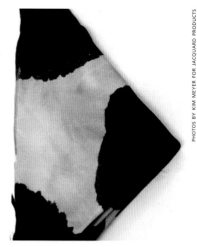

 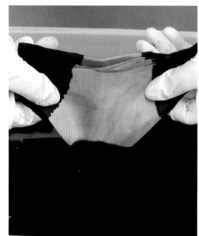 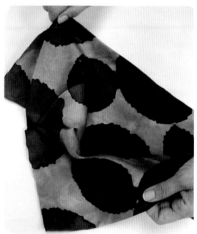

PHOTOS BY KIM MEYER FOR JACQUARD PRODUCTS

tendency to spread and run. One such product is called No Flow. To use it, and similar products of its type, brush the solution onto the fabric and let it dry. For even coverage, it's best to "paint" it on with a wide foam brush. You'll then be able to paint, stamp, or otherwise apply a liquid dye to the treated fabric, and the color will not flow. Using the brush will also allow you to achieve sharp, crisp edges and outlines in your designs.

Thickened dyes are best set by steaming.

Fabric that has been painted with thickened dyes will have a totally different look than fabric painted with the organic swirling, flowing colors produced with dyes in their liquid form.

DIP-DYEING

Another fun technique that combines the expected with the unexpected is fold-and-dip dyeing. You can alter this basic method by devising different folding patterns or dipping vari-

Left column: Fold a length of fabric into triangles, pressing each fold as you go.

Middle column: Dip each corner of the triangle-folded fabric into dye.

Right column, top: The dipped fabric will look something like this. Bottom: *Unfold the fabric only after it has completely dried.*

ous materials such as paper or stiff fabrics into the dye bath. This is a delightful project for introducing children or other beginners to the marvels of improvisational art. Here,

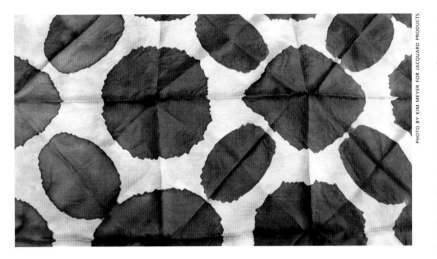
PHOTO BY KIM MEYER FOR JACQUARD PRODUCTS

SUMMING UP

This may be a short chapter, but you can accomplish a great deal with the few simple techniques we've explained here. You'll see numerous examples of immersion dyeing as well as ombrés and gradations throughout this book. Some stand on their own, while many more become the background for other techniques.

We don't talk about level, uniform, even colors when dyeing. Michelle mantra is "Perfection is boring." Other books contain information on perfect base-dyeing if you are interested in learning about it. At times we prefer to begin our projects using a commercially dyed fabric and get right down to the exciting part by overpainting, printing, or employing another decorative technique.

Michelle shows you one of dip-dyeing's many possible effects.

Fold and press a piece of fabric into a triangle shape.

Wearing rubber gloves, dip just the corners of the triangle into a dye bath.

The fabric will look something like the photo in the upper right-hand corner of page 56.

Let the folded fabric dry completely. Resist the temptation to unfold it and take a peek. (I recommend doing this by beginning another project.) Even though you can predict to some extent what the finished fabric will look like, it's always exciting to unfold it and see all the variations.

Above: *The finished dip-dyed sample.*

Below: *Here's another example of dip-dyed fabric.*

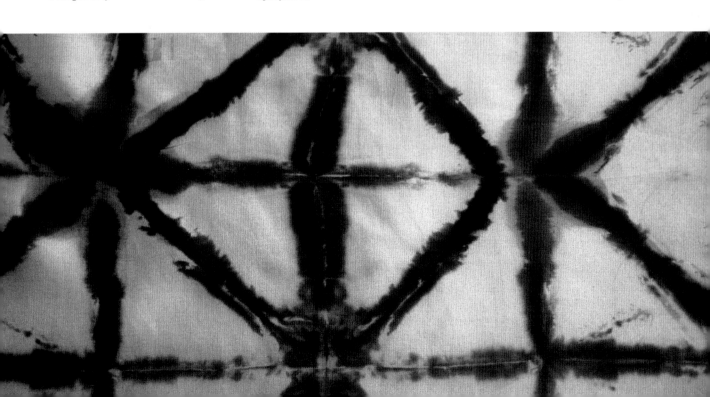

THE DISCHARGE PROCESS

S o far we've been talking about adding color to fabric. The bleach discharge process works in reverse. It's a subtractive technique, one that removes—or discharges—color. The results are beautiful, dramatic and exotic—almost mysterious. It's as if we are given a chance to see what was once there on the surface but has since disappeared. Although the term "pentimento" usually refers to an alteration made in a painting that later shows through, it could also be used to describe the interesting visual effects of discharge.

PROCESS OVERVIEW

Anything that will remove color from fabric—common household bleach, color remover, or any of the specialty products available—has to contain powerful chemicals, so you should work outdoors or in an area with excellent ventilation. You'll also need to work quickly, as the bleaching action takes place rapidly.

You can bleach-discharge almost any non-protein-based, dark fabric, meaning any fabric made from fiber that comes from a plant rather than an animal. Bleaching proteins without damaging them is not easy. Your hair, for instance, is a protein. Do *not* use bleach to discharge fabrics made of wool, cashmere, alpaca, camel hair, or silk. The process will destroy those fibers. Even though much of this book is devoted to silk, this is one technique that most definitely does not work on silk. It's not a good idea to experiment with in this case. The process works fine on cotton, linen, viscose rayon, and synthetics. Rayon velvet will probably be the most fun to work with; it produces intriguing and unexpected colors, and of course velvet feels so luxurious to the touch and catches the light in a unique way.

Michelle often uses ordinary household bleach for discharging. Take precautions to protect your health. Consider wearing a respirator, and by all means do not use the discharge process around children. If you have breathing difficulties, other health issues, or if you arc pregnant, you might want to avoid discharging altogether. Talk to your doctor to find out for sure.

SPECIALTY PRODUCTS

Bleach thickeners such as Monogum make it easier to stamp and stencil with bleach. The product comes in a powder, to which you add water to form a paste. After the paste has set for a few hours, add bleach. These instructions are just meant to give you the basic idea of the process. You should carefully follow the directions on the bleach thickener package. (You can stamp and stencil with unthickened bleach also; thickener just gives you more control.)

Some directions for discharge techniques advise you to add vinegar to the rinse cycle when you wash discharged fabrics (to halt the bleaching process). Most textile artists discount its usefulness. Specialty suppliers offer products such as Anti-Chlor specifically formulated to neutralize the bleaching process. Add a small amount of it to a large pail of water and stir well. When the fabric has discharged to a desirable point, rinse it immediately in plain water, then plunge it into the Anti-Chlor solution for five minutes or so. Rinse well. Follow the neutralizing product's directions; ours are just an overview.

There is at least one discharge paste formulated to discharge dyes—*and* you can use it on silk. Because it's thick, it behaves a little differently than bleach. Directions usually require letting the paste dry on the fabric, then steam-setting or ironing it away. Do this with plenty of ventilation; avoid breathing the fumes. If you're pregnant, asthmatic, or sensitive to airborne substances, talk to your doctor about working with discharge.

GETTING READY

Pre-wash any fabrics that you are going to bleach-discharge to make sure that the sizing (a

chemical treatment added by the manufacturer to give body) won't interfere with the bleach or produce harmful fumes.

Begin by diluting the bleach with an equal amount of water. If the discharge process is slow, or if the color does not discharge very much, add more bleach. It's better to begin with a weak solution than one that is too strong.

Experiment on an edge or scraps of the fabric you will be using before beginning your main design. You want to see what color is produced by discharging the dye in the fabric and how long the bleaching process takes. With some fabrics, you'll be able to see a dramatic change within the first couple of minutes; some

fabrics even discharge almost instantly. Other fabrics will take longer. Sunlight sometimes speeds up the process. If the discharge is happening too quickly for your purposes, dilute the bleach with water. (There are a *lot* of variables involved in this technique.)

Read all the instructions in this chapter before you get started. You'll need to be near a washing machine that's already filled with water and detergent. When a powerful chemical reaction is taking place, timing is important. You won't want to leave the fabric unattended while you fill the machine. If the bleaching action continues without your attention, it can remove more color than you want it to, passing beyond the beautiful shade into whiteness. Worst-case scenario: It can eat right through the fabric, leaving holes. When discharging large pieces of fabric, work in increments, repeating the "painting," rinsing, and drying

processes. (If you don't have access to a washing machine, substitute a large vessel of water and detergent. Stir the fabric around for several minutes, then stir occasionally. Rinse afterward.)

The discharge process lends itself perfectly to freehand "painting." But don't use your good brushes for this. Reach for a cheap one you can toss out afterward. Foam brushes work well. In fact, you can cut grooves and textures into their surfaces with craft scissors to get an even more textural effect. Michelle likes inexpensive natural-bristle brushes (toss-away chip brushes) from the hardware store.

GETTING STARTED

After stretching the fabric, pour a little bleach into a container that will be convenient to dip a brush into and easy to hold in your hand.

Below left: *Working in a well-ventilated area, pour common household bleach and water into a small container.*

Below right: *Michelle begins "painting" with bleach.*

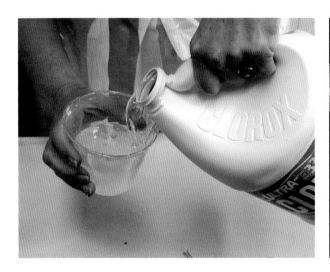
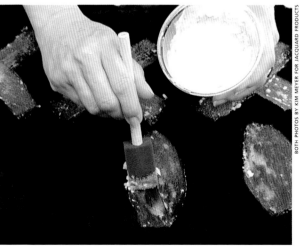

"Paint" a simple design (remember the power of repeat motifs) onto the fabric, working quickly. Watch it carefully. There is no way to predict how fast the color will disappear.

When the color is to your liking, toss the fabric into the already-filled-and-ready washing machine. Let it go through the wash cycle on "delicate" to stop the action of the bleach.

Try this with maroon, russet, indigo, and other dark shades of velvet. It's always a surprise to see what colors appear. Different black velvets that appear identical may yield results that are quite different due to variations in fiber content and dye formulas.

If you become fascinated with the discharge process and want to experiment more, you can hand-"paint" with a syringe,

The black velvet has discharged to a pale gold color.

rather than a brush. You can also investigate stamping, stenciling, and sponging. Spraying bleach, especially when you've masked off design areas, produces a wonderful effect. You can lay shapes cut from cardboard on the fabric before spraying, or use actual objects. Big fern leaves are especially good. We've seen plastic toys and jigsaw-puzzle pieces used for this purpose with interesting results. You must take extra precautions against breathing the bleach vapors when you are spraying. We highly recommend wearing a mask; wearing a respirator would be even safer.

After washing and drying the fabric, you can paint the bleached areas to get areas of color, even intense shades. You cannot achieve such shades when you are painting directly on dark colors, and for this reason alone, the discharge process is interesting.

VELVET MUDCLOTH

Here's how Michelle made her velvet mudcloth jacket.

Taking as her inspiration the traditional West African fabric known as mudcloth, or *bogolonfini*, she chose simple motifs. These, of course, are particularly suitable when the fabric discharges quickly and you don't have the time to apply complicated designs.

Depending on your work area, it may not be necessary to stretch the velvet. Its own weight might hold it in place. Otherwise, stretching it on a large outdoor table or between sawhorses will give you the control you need and enable you to paint a large area of fabric at one time. Remember, though, that you'll be working quickly. Don't use lots of tacks or any stretching method that takes time to disassemble. In fact, you can lay fabric down on a lawn for discharge, depending on its weight and how windy the day is.

Use a 1-inch brush. Because the designs are bold, there is little to be gained by using a delicate brush. Choose a foam or chip brush that you can just simply discard afterward.

Fill the washing machine (or a large vessel) with water and detergent before you begin and stop the cycle so that it will be ready and waiting.

Do a test piece first to get

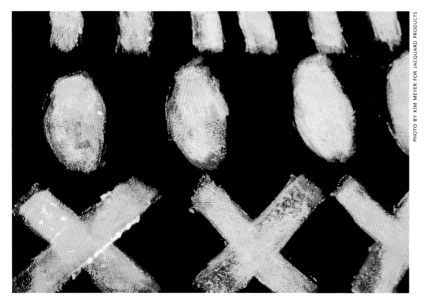

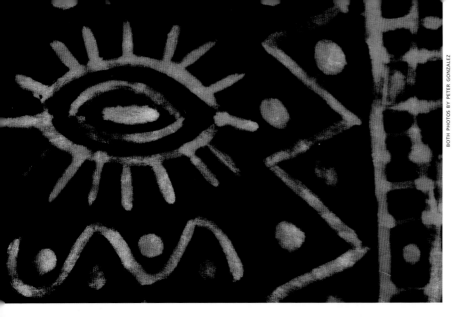

an idea of how quickly the dye will discharge. If it happens quickly, you might want to simplify your planned design. Or, if a color appears rapidly and fades away to something less interesting, you'll know to plunge it into the water immediately while that color remains.

Quickly paint a series of simple design elements—lines, dots, crosses, x's, squiggles— onto the fabric. You may place them in loosely arranged rows or at random. It isn't necessary to consider the pattern layout; think of it as an allover design.

As soon as the velvet discharges to the color you want, plunge it into the water and run the machine on gentle cycle. Then toss the fabric into the dryer.

Choose a very simple pattern, with no darts or fussy details. The fabric itself is the statement, and ornamentation or a highly constructed garment design would most likely only detract.

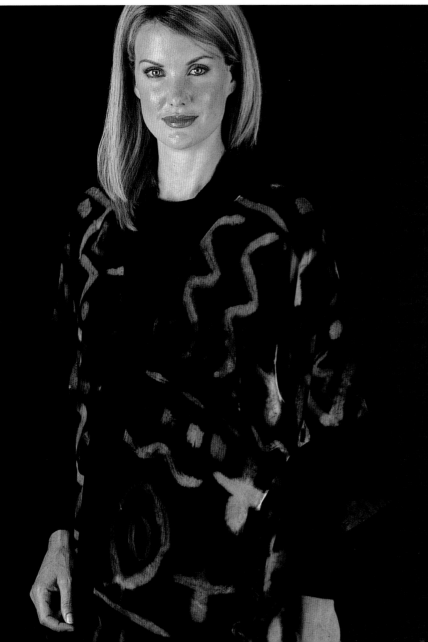

Above: *Bold, almost aboriginal motifs, are good for discharge techniques.*

Below: *The jacket is inspired by the* bogolonfini *cloth of the people of Mali, in West Africa. True mudcloth is a cotton textile dyed by soaking it in a "tea" made from various leaves, then painting it with fermented, iron-rich mud.*

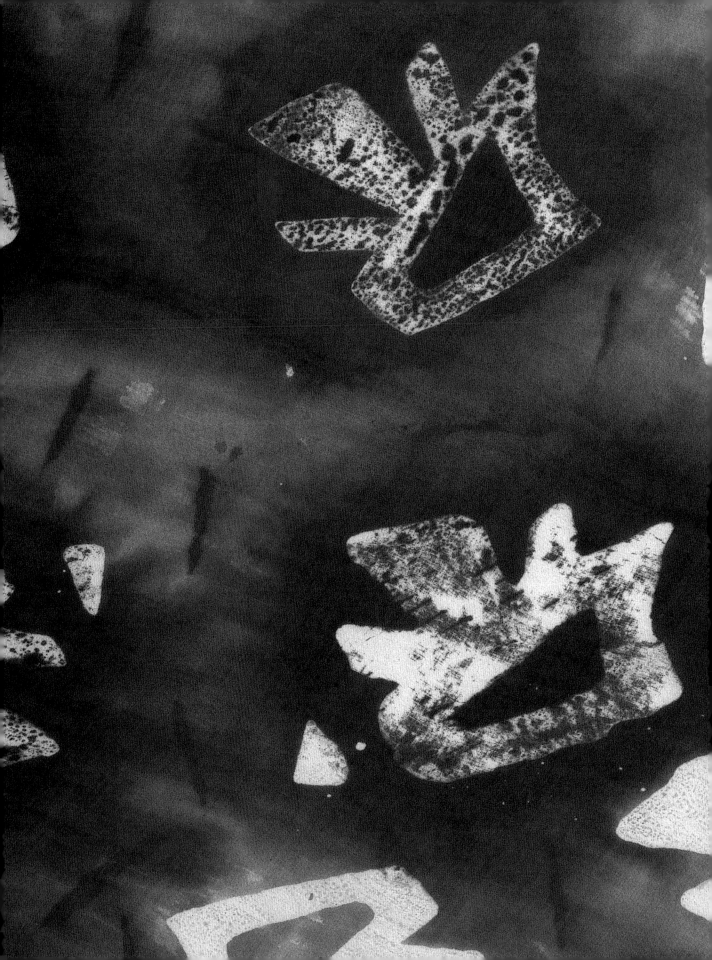

MAKING MULTIPLES

A world of possibilities opens up when you begin to explore stamping, stenciling, printing, and silkscreening. Making multiples of a motif or group of motifs produces exact replicas without the bother of attempting to copy a freehand design. Draw it once, and reproduce it as many times as you like. From purchased rubber stamps and stencils to monoprints to leaves from your own backyard, you'll find hundreds of ways to create repeat motifs or one-of-a-kind masterpieces. Layer images over fabrics you've sprayed, sponged, or scrunch-dyed for multimedia effects, or layer images on "virgin" fabrics for a crisp and clean look.

STAMPING

L et's start with rubber stamps because they are so popular and widely available. Thank the community of paper artists for this, as well as the huge phenomenon of scrapbooking. Fortunately for fabric artists, most of these wonderful little tools work for us just as well.

When you go shopping for stamps (look in general arts and crafts stores, scrapbook shops, and museum stores), you'll find all kinds of designs, ranging from sweet little bouquets to bold and graphic shapes. We tend to recommend the latter for two reasons: In this book, we're investigating Michelle's style, which is bold and graphic. Another reason is that simpler stamps work better with wax, paint, and dye—the more intricate, detailed designs require ink on paper to get their full effect.

Whether you're using a purchased stamp, a hand-carved stamp (which we'll get to in just a minute), or a found-object stamp, the basic technique for applying the stamp to fabric is the same.

Apply paint to the design area of the stamp. There are several ways to do this. You can use a small roller, a brush, or a make-up sponge. You can

also stamp with inks if you're working on smooth, finely woven fabrics. In that case, you would use a stamp pad with inks specially formulated for use on fabric.

Press the stamp down on stretched and pinned fabric, being careful not to rock or move the stamp while it's in place. Lift up the stamp. Repeat as you like—you'll just have to be a little more careful with adjacent motifs. The photographs on page 67 show you just how easy this is. Michelle works on a lightly padded surface, because she finds that this gives her better results.

After you've played with purchased stamps and have seen what you can accomplish

Rubber stamps are used to decorate scrapbook pages, ornaments, envelopes, altered books, and other applications. These are from Rubber Stampede.

with them, you'll no doubt want to make some of your own. Here's how to do it. Begin by drawing or transferring the design to paper.

Next, use transfer paper to reproduce the design on the stamp surface. You can even iron a black-and-white photocopy onto certain stamping products like Speedy Stamp. Dover books are an excellent source of botanical designs and copyright-free motifs from different eras and cultures.

With a marker (like a Sharpie), go over the design lines.

PHOTOS, BOTH PAGES, BY KIM MEYER FOR JACQUARD PRODUCTS

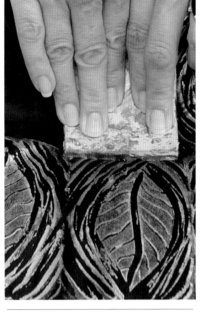

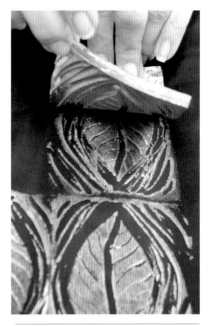

Above: *Apply paint (here Michelle used a metallic one) to the stamp.*

Above: *Don't be shy—stamping requires lots of pressure.*

Above: *This leaf stamp was carved from Speedy Stamp, a product that makes it easy to create custom designs.*

Below: *Acrylic paints in colors like amethyst, sapphire, and peridot are stamped on velvet.*

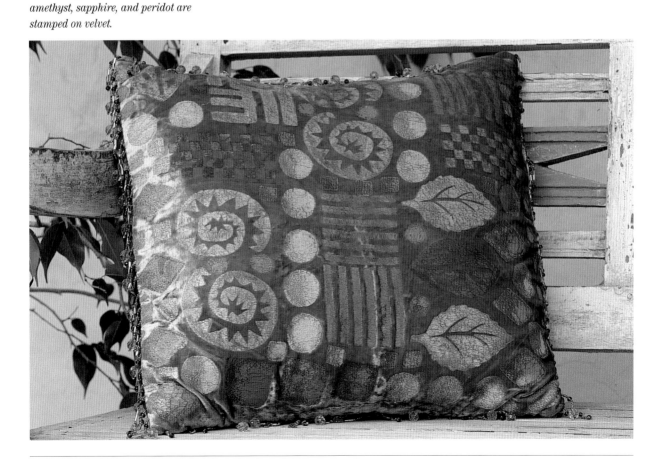

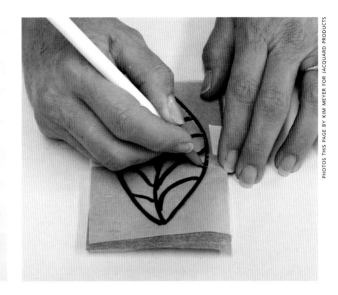
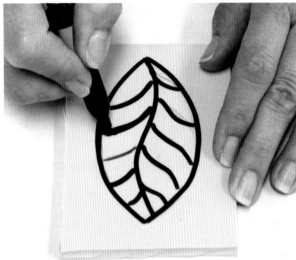
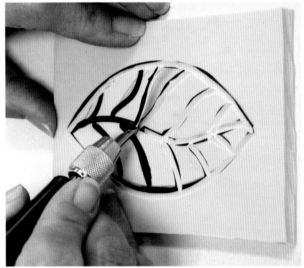
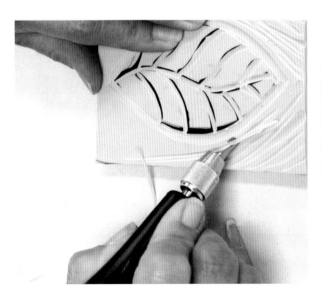

Top row, left: *Stampmaking materials.*
Top row, right: *Draw or trace your design on paper.*

Middle row, left: *Go over the design with a marker.* Middle row, right: *Carve interior lines with an X-Acto knife.*

Bottom row, left: *Cut out exterior shape.* Bottom row, right: *Handmade stamps.*

Use an X-Acto knife or other art knife to carve interior lines. Always cut *away* from yourself to minimize the risk of an accident. Then cut out the exterior shape.

Now you have a rubber stamp that is ready to use. You can see in the photo on page 67 that the stamp is flexible, thus allowing you to lift up one side of it to check the impression.

You can take your stamp a step further by gluing it to a block of wood or Lucite (a clear plastic). Use a strong adhesive like E6000 or a hot glue gun. The stamp will no longer be flexible, but it will be easier to use. And you aren't limited to the products sold especially for stampmaking. The photograph on page 68 (lower right-hand corner) shows you just a sampling of other possibilities. Clockwise, from upper left, you'll see balsa-wood strips glued to a wooden block, carved balsa-wood shapes covered with felt and glued to a wooden block, clothesline cord glued to a wooden block, and wine corks

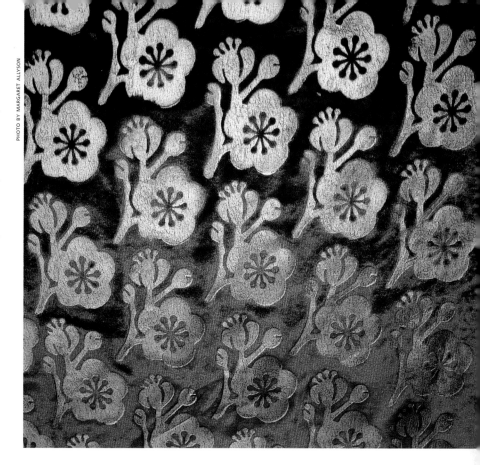

PHOTO BY MARGARET ALLYSON

covered with felt and glued to a Lucite block.

Potato printing, which you probably did in elementary school, is one version of stamping, as are those magnificent Asian fish prints you may have seen. You can use all kinds of edibles for stamping: halves of artichokes, onions, apples, ends of celery stalks or rhubarb.

In Chapter 7, when we talk about wax resist, you'll discover more ways to use different kinds of stamps.

Michelle used purchased stamps made by Rubber Stampede and Plaid Enterprises to make the Mumbo-Jumbo Pillow shown on page 67. She used ice-blue panné velvet and a palette of shimmery "mer-

Above: *Metallic paint makes these repeating cherry blossoms shimmer on the velvet fabric.*

Following spread, left: *You can see that same cherry blossom design surrounding the print in the center in this dramatic pillow. The Greek key is stenciled.*

Following spread, right: *Palm Tree Shower Curtain. These palm tree motifs were rubber stamped onto a purchased curtain with an oversized stamp from Rubber Stampede. The Greek key was stenciled.*

maid" colors in acrylic paint. After the paint had dried, she ironed it on the back. Notice that the motifs are very close together; some even overlap a little. As a finishing touch, she added beaded fringe.

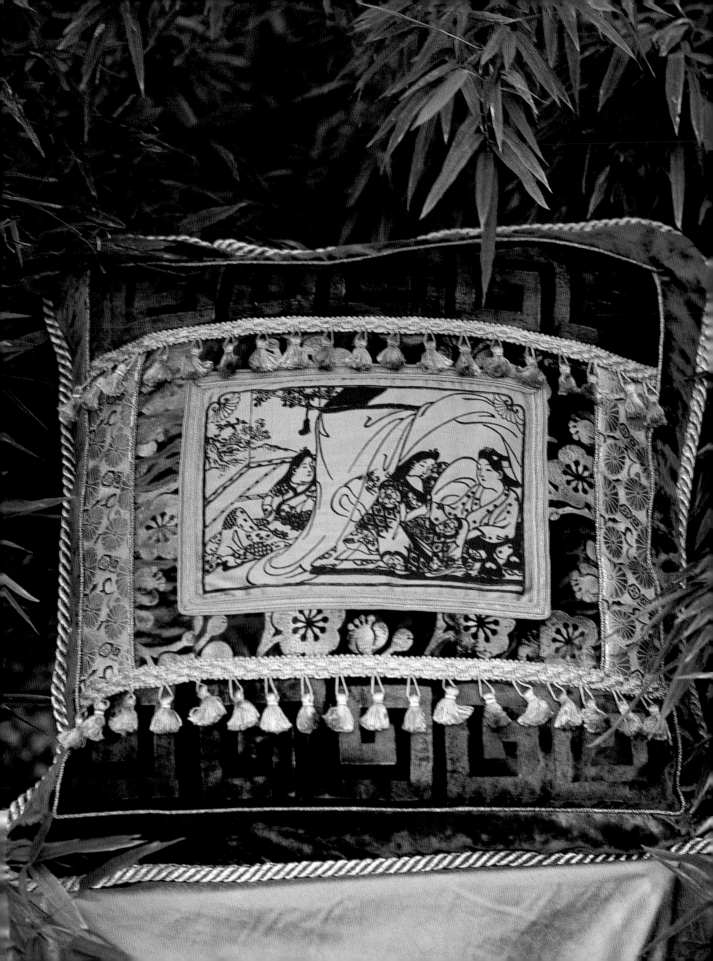

MONOPRINTING

PHOTOS THIS PAGE BY KIM MEYER FOR JACQUARD PRODUCTS

Strictly speaking, monoprinting means making *one* print. However, the first version of this technique that we're going to show you works marvelously for repeat designs.

Here's a brief overview on monoprints: Apply paint to a surface, usually a Lucite or plexiglass block or a plastic drop cloth. Use "wipe-out" tools (explained below) to remove areas of paint to form a design. Then press the fabric onto the painted surface, or— for smaller designs—press the block onto the fabric.

Wipe-out tools are hard rubber tips attached to wooden or plastic handles. These are readily available in catalogs or your local stores. However, you are not limited to that selection: Ordinary household objects can create equally interesting effects. Combs and kitchen tools and the like can be used to produce the look you're going for. Shop the hardware store for tools you might not have considered, including faux-finish tools. You can even use the eraser end of a pencil.

Let's begin our exploration with a Lucite block. (Refer to the photos on page 73.) Paint an entire flat surface of the

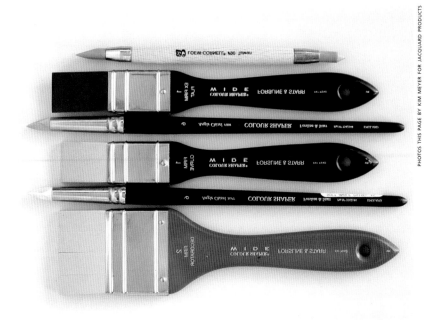

block, then "draw" with a tool to remove paint in selected areas. Michelle has chosen a wavy stripe as an example.

After wiping out the paint, press the block onto stretched-

Above and left: *Paint a piece of foam or Lucite, then use wipe-out tools to draw designs in the paint. Shown with brushes are special tools. You can use lots of other things, too—including tools from the hardware store designed for grouting or faux finishes.*

Opposite top: *Monoprint sampler on cotton velveteen.*

Opposite, below left: *Paint one surface of a Lucite block, then remove the paint with a wipe-out tool.* Opposite, below middle: *Make a simple design in the paint.* Opposite, below right: *Print one motif or a repeat design.*

and-pinned fabric to print.

Repeat the steps if you want an overall design, a border, or a striped effect.

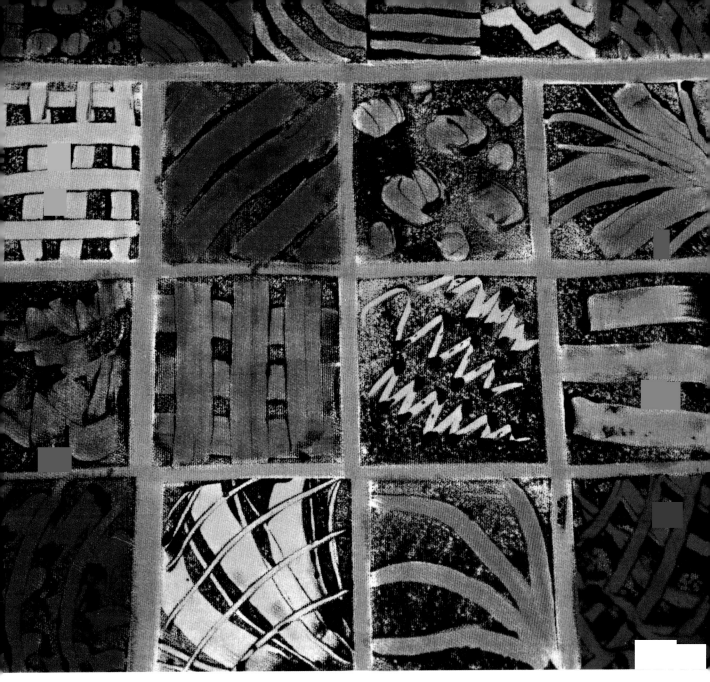

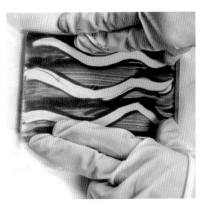

The following method of monoprinting lends itself to larger designs. It's perfect for printing a prehemmed scarf, for instance. To begin, lay a plastic drop cloth on your work table. Anchor it with T-pins if the plastic is not heavy enough

Below: This scarf was first scrunch-dyed, then monoprinted with metallic gold paint and a rectangular Lucite block. After the paint dried, Michelle overprinted with dyes. The acrylic paint acts as a resist, keeping the dyes from penetrating the printed areas.

to remain in place. You don't want it sliding around. Paint the entire design area with thickened dye.

Wipe out selected areas to remove the dye. In this example, Michelle uses a combing tool, often used in faux-finish techniques, to create a simple design.

Now lay the fabric over the painted surface.

Roll a brayer (a rolling pin will also do) over the fabric several times to transfer the dyed image.

Lift the fabric carefully from the dyed surface to avoid smudging the design. Depending on the size of the fabric, you may need help to do this.

Top row, left: *Brush paint or thickened dye onto a plastic drop cloth.* Right: *Wipe out a design—here Michelle uses a combing tool.*

Middle row, left: *Lay the fabric to be printed over the painted area.* Right: *Roll a brayer (shown in photo) over the fabric to be printed.*

Bottom row: *Lift the fabric to see the printed image.*

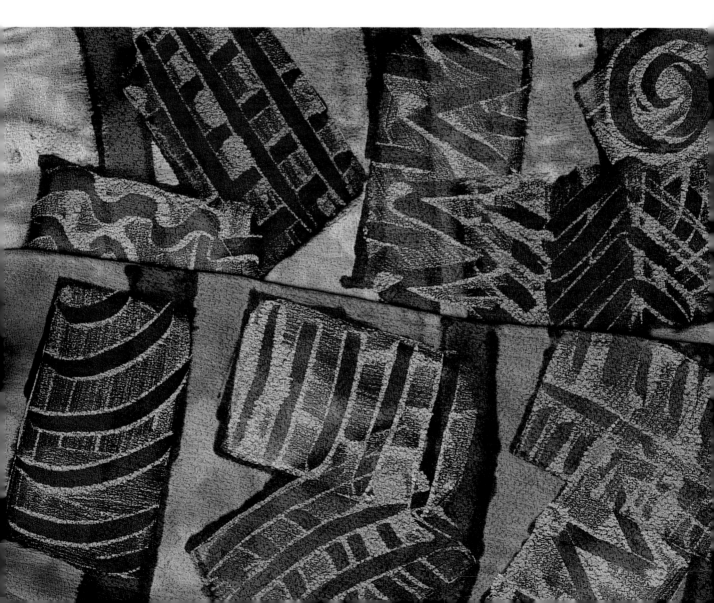

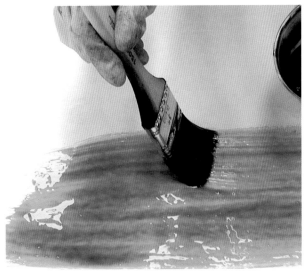
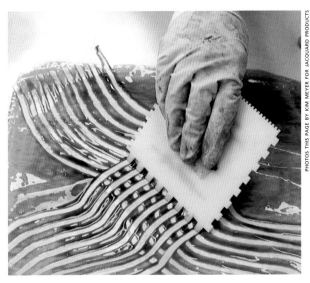
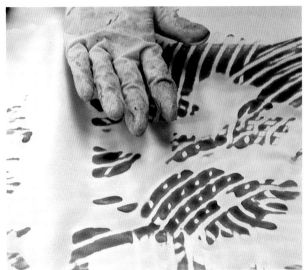
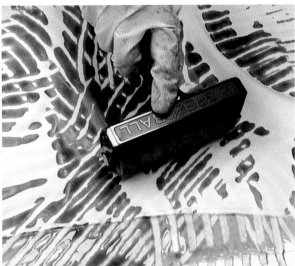
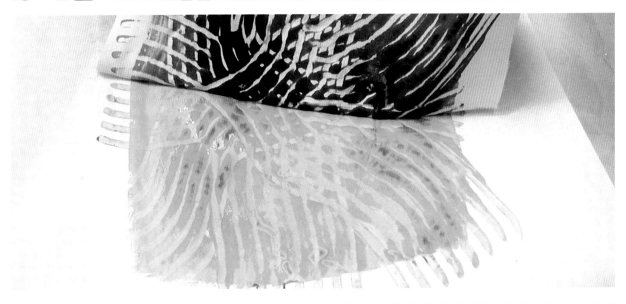

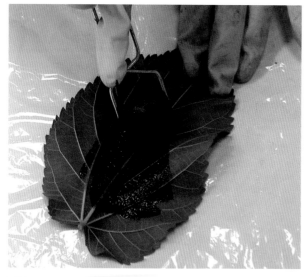

PHOTOS THIS PAGE BY KIM MEYER FOR JACQUARD PRODUCTS

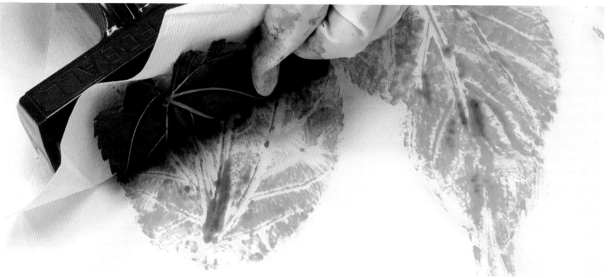

You can also monoprint with a leaf. Nothing could be simpler, yet the intricate, natural variations make a rich pictorial image that would be hard to achieve otherwise. This is a process similar to that for making fish prints, but, obviously, more appealing in some ways.

Choose a good-sized leaf and lay it down on a plastic drop cloth. Cover the veined side of the leaf with paint or thickened dye.

Lift the leaf from the plastic and lay it paint side down on the fabric to be printed. Cover with a piece of muslin or clean paper and roll over it with a brayer.

Lift one edge to check the impression; roll again if necessary. Use the same leaf again to print, or create visual interest by selecting another leaf from the same type of plant for a repeat design. Or use three different leaves from the same plant—small, medium, and

Top left: *Paint the veined side of a leaf with paint or thickened dye.*

Top right: *Lay the leaf paint-side down on fabric. Cover with paper and roll with brayer.*

Above: *Lift the press cloth to see the printed leaf.*

large. This will give you visual interest in scale. (You can keep a leaf fresh overnight by wrapping it in a damp paper towel and a zip-type plastic bag.)

STENCILING

Stenciling opens up even more options for repeat designs or realistic motifs. Like rubber stamps, stencils are available in a wide variety of designs. For her example, Michelle shows a simple Greek key design.

The first step is to apply a spray-on stencil adhesive to one side of the stencil. The adhesive holds the stencil firmly in place, minimizing the chances of smudges and seepage.

You can apply paint in several ways, which we'll show you here. No matter what applicator you choose, you'll want to dip it into the paint and remove a lot of the excess on a paper towel. Less is truly more in stenciling, as too much paint can run beneath the stencil and mar the design.

Roll paint on with a small roller brush, a stencil brush, or a Spouncer (a rounded foam brush). Michelle used metallic green paint in the project shown here.

Lift up one end of the stencil to check the impression. If it is to your liking, carefully remove the stencil to see your finished design. If you're planning to repeat the design, let the first stenciled area dry before you go on with the next.

PHOTO BY KIM MEYER FOR JACQUARD PRODUCTS

Left: *There are many simple geometric stencil shapes available.*

Below, clockwise from upper left: *Apply a spray-on stencil adhesive. A small roller, a stencil brush, or a Spouncer (a foam applicator) are all great for stenciling.*

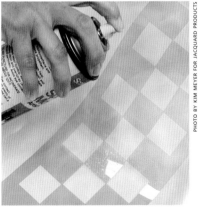

PHOTO BY KIM MEYER FOR JACQUARD PRODUCTS

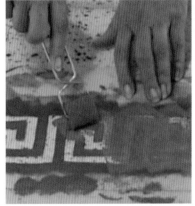

PHOTO BY STACY SCHOOLFIELD

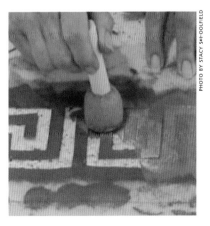

PHOTO BY STACY SCHOOLFIELD

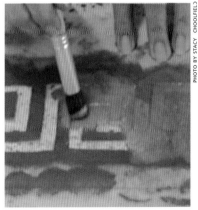

PHOTO BY STACY SCHOOLFIELD

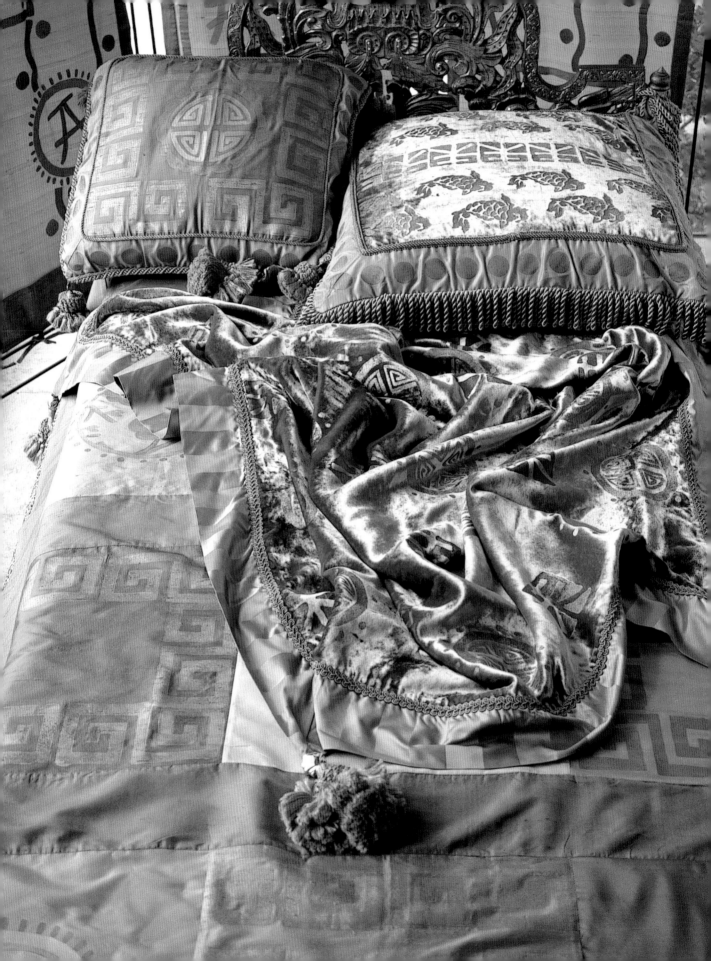

SILKSCREENING

Forget everything you thought you knew about silkscreening. Forget the involved photo processes, messy chemicals, smelly ink. Michelle's silkscreening method is quick, versatile, easy, and fun. You can go from sketch to screened fabric in no time.

You'll need a blank silkscreen, a squeegee, and some textile ink, acrylic paint, or thickened dye.

The basic screen itself consists of a wooden frame on which a piece of open-weave nylon or poly fabric (no, it's not really silk) is stretched. Mesh sizes—the openings in the weave, the distance between the threads—vary from very fine to coarse. When you force the paint through the mesh with the squeegee, it prints an image. Move the screen around, and images multiply like magic. We'll tell you how to use masking tape, adhesive paper (like Contac paper), and other common ingredients to construct your design.

A squeegee, of course, is a hard slice of rubber with a

Opposite: Almost all the pieces in this silk and velvet Asian ensemble are stenciled or stamped. Some of it was hand-painted as well.

handle, much like what you'd use to clean windows. You'll want one specially made for silkscreening, though in a pinch you can use other scraper-like items—even a credit card.

SILKSCREENING,

or seriography, originated in the 1920s. It was used primarily for mass-producing posters for advertising and inspiring patriotism during wartime. It is a sophisticated form of stenciling. In traditional silkscreening, a different screen is cut for each color. These are overlaid in order, registered (aligned), and then printed.

Above: *This is all you need to get started for silkscreening.*

Price? You should be able to equip yourself with a silkscreen and a good quality squeegee for $40 or less. Your local art supply stores or arts and crafts shops should carry silkscreens and squeegees.

As soon as you get your new silkscreen, scrub the front and back of the mesh with a scouring pad and an abrasive cleaner (like Ajax). Let it dry, then cover all the wooden parts with duct tape or masking tape; this keeps pigment from seeping into the wood and through to the fabric. Apply another

layer of tape around the inner edge of the screen for the same reason.

MASKING TAPE

Michelle demonstrates a windowpane check design with masking tape in these photos. Of course, these square checks could become diamonds, rectangles, or other geometric shapes with a different arrangement of the tape.

On the top (flat) side of the screen, apply the masking tape. Because the tape acts as a resist, it's the spaces in between that matter. They will become the printed design, the image you will see. In addition to masking tape, consider creating designs with self-adhesive sales tags or those little circles used to reinforce the holes in notebook paper.

Lay the screen on the stretched and pinned fabric. Tip one end of the screen up.

This forms a little ditch, or "well," protected by tape, into which you can pour your paint or dye thickened to the consistency of yogurt. (After a couple of prints, you'll get a sense of how much paint it will take to screen the design you have created.) Notice that Michelle runs a line of paint across the width of the screen. (Also see, below, the tape that protects the edges of the screen.)

With the screen still tilted off the fabric, drag the squeegee

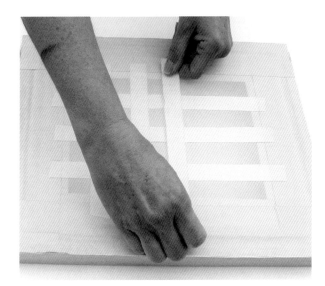

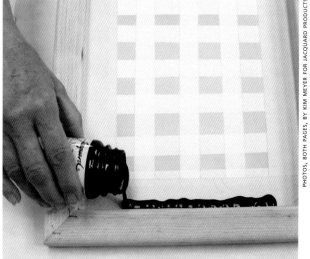

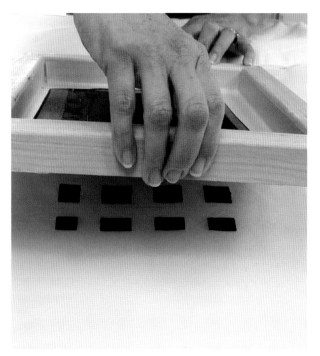

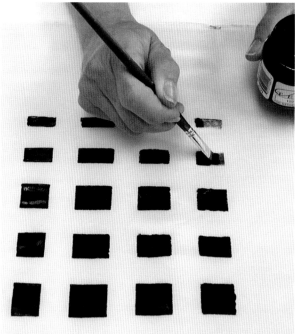

Opposite page, clockwise from top left: *Use masking tape to make silkscreen designs. Lift one edge of the screen; pour paint into the "well" created. With edge of the screen lifted, drag the squeegee through the paint and across the surface of the screen. With the screen flat on the fabric, draw the squeegee toward you to make a print.*

Above left: *Hold one edge of the screen down; lift the other edge to see the design.*

Above right: *Touch up any rough areas with a small brush.*

across the entire surface. This distributes the paint evenly in preparation for screening. This is known as "charging" the screen. (At this point, it's a good idea to make a test print on some scrap fabric or paper—even newsprint will do.

See if there is any seepage or spotting in places where excess paint is coming through. If it is, patch the area with tape, working from the flat side that goes against the fabric.)

Lay the screen flat on the fabric and pull the squeegee toward you at an angle, with some degree of pressure. You'll need to pull it anywhere from one to three times to force the paint through the screen.

Use your hand as if it were a hinge to hold one end of the screen firmly in place while you lift the other end to check the image. If you find that it's necessary, pull the squeegee across the screen again.

What if you haven't applied enough paint? Tilt the screen, add a little more paint to the well, and recharge the screen. Then pull the squeegee again.

All right, there is one step in silkscreening that is not especially fun. The minute you finish pulling all the designs, you have to wash the screen or the mesh will be clogged. Yes, the very minute. So you'll want to be fairly close to a sink or tub. Your ideal set-up would include a spray attachment for the faucet to thoroughly clean the screen. Michelle uses a mild dish detergent and a dish scrubber brush for cleaning.

Let the screen dry before the next use. This doesn't take long at all; however, if silkscreening becomes one of your favorite techniques, you might want to buy a second screen to use while one is drying—or use a handheld hair dryer to accelerate the process.

Touch up the design, if necessary, with a small brush.

ADHESIVE PAPER

You are not limited to straight-line designs created with masking tape. By using an adhesive paper (like Contac paper) as a resist, you can produce much more complicated shapes such as curves, swirls, and the like.

Cut a piece of Contac paper the size of your screen. Draw or trace your desired design onto it with a Sharpie marker. Remember that you are blocking areas where paint will not penetrate; you are, in a way, designing in reverse. Whatever areas you cut away will show up as your finished design, while the areas that remain will be masked; they will be the negative space.

Cut away the areas that comprise the design. An X-Acto knife is the best tool for this step. Cut on a self-healing mat (a mat made for use with art or craft knives and rotary cutters). Because Michelle wants the lightning bolts to be the primary design element, she cuts them

Clockwise from top left: *Draw your design on adhesive paper; with an X-Acto knife, cut out the area to be printed. These cheery little hearts were silkscreened with the adhesive paper method.*

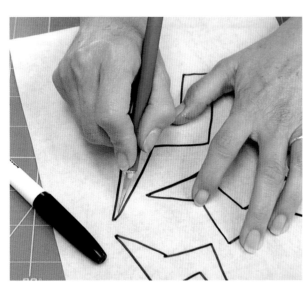 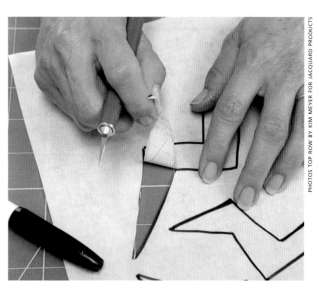

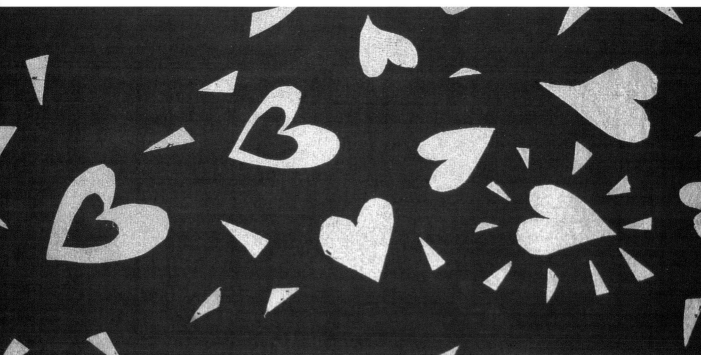

out. All the remaining areas become background. Don't discard the cutout pieces; you can use them in other projects as a resist and spray or sponge around them.

Now peel the paper backing away slowly and carefully. You might even ask a friend to help you with this step if you're doing an intricate design. Lay the adhesive side of the Contac paper onto the top (flat part) of the screen.

Pour paint into the well, charge the screen and print just as explained for the masking-tape method. Don't forget to wash your screen immediately.

When you are screening a repeat design, you'll want to make sure that previously screened motifs are dry before placing the screen on nearby areas. To speed up this process, use a handheld hair dryer. If your work surface is big enough, however, you can screen several motifs, let them dry, and then go back to screen print designs in between them—with the same screen or with a different one, in a different pattern.

Lightning Bolt Table-Topper. *You almost expect a gypsy to appear at this mystical little table. The covering was made by silkscreening circles and lightning bolts with metallic paints onto rich maroon velvet. The motifs are applied in a fairly random design. Bullion fringe sewed around the edges adds a little weight and makes the cloth drape nicely. The underskirt is merely a circle of fairly heavy tiger-printed felt.*

USING RESISTS, OR WAX ELOQUENT

Wax is a wonderfully versatile resist material. Paint or stamp it onto your fabric before dyeing or painting for results ranging from the thinnest lines to the boldest blocks. Unlike authentic traditional batik, which demands multiple wax applications and dye baths, wax resist requires few steps: applying the wax, dyeing or painting over it, removing the wax, and steam or heat setting. And, unlike using gutta to delineate and separate small areas of silk in preparation for detailed painting, applying wax is neither tedious nor picky.

GETTING READY

Before you get started with the wax, stretch your fabric. This is one technique you shouldn't do on a padded table. Instead, stretch the fabric on a frame or a pair of sawhorses with push pins. By the way, when working with velvet, Michelle almost always applies the wax and dye to the smooth side of the fabric. Notice, however, that when she uses cold-water wax resist, she works on the pile, or nap, side.

A note about safety: Work in a well-ventilated area with no pets or children. If you are alert, you will most likely never have a wax accident, but there's no sense in tempting fate. Minimize your distractions, and take care to arrange an efficient work area.

First, gather up some tools. Depending on your project, you might want to get a traditional *tjanting* tool, which is a tiny vessel with a metal pouring spout mounted on a handle. However, you can enjoy countless hours of working with wax resist and never use a *tjanting* tool. Sea sponges and blocks of

natural foam are good tools; so are ordinary brushes and paint rollers. Using a brush in hot wax renders it useless for other media, but there's no reason you can't re-use the brush for wax. Michelle uses a mixture of half beeswax and half paraffin for wax resist. You can also purchase batik wax. Melt equal parts of these waxes at low temperature in an electric skillet or double boiler that you don't intend to use for cooking. Michelle uses an electric skillet, but she takes extreme caution with both temperature and attentiveness. She keeps the heat very low and never lets herself be distracted. We strongly encourage you to use a double boiler for safety.

There's a sense of timing, which you'll soon discover, to leaving your tools in the wax.

Wax resist supplies : Tjanting *tool, bamboo brush, wide brush, cut foam, segmented brush, sea sponge, beeswax, paraffin wax.*

SAFETY

• Work in a well-ventilated area. Michelle likes to work outside. However, beeswax can attract bees, so if you are allergic to insect stings, you might want to avoid working outdoors.

• Keep wax temperature at 180 to 200 degrees. If wax begins to smoke, lower heat immediately.

• Never leave wax pot unattended, even to answer the telephone.

• Do not inhale fumes from hot wax. If you are asthmatic or pregnant, consult your doctor.

• Take care not to touch hot wax or let it spatter onto your skin.

• Do not use a pot that has been used for wax for cooking or food preparation.

Just as you want ingredients at room temperature when you're baking, so your "ingredients"

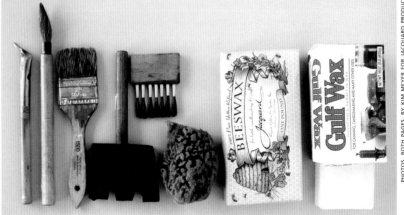

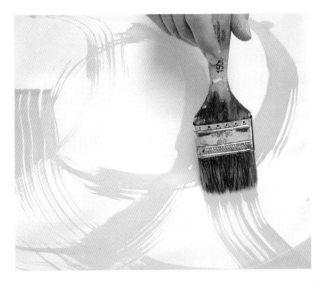

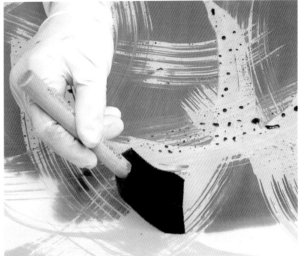

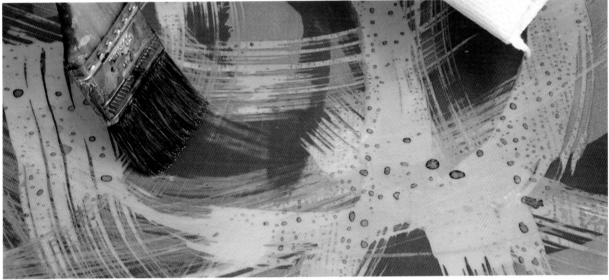

for working with wax should also be at a certain temperature. Up to a certain point, it's all right to leave brushes and daubers and the like resting in the hot wax until you're ready for them. Foam rollers, brushes, and daubers are the most susceptible to heat, so keep a close watch on them. A few minutes in the hot wax is fine; half an hour would singe the brushes.

As you can see in the photo on page 86, materials for a wax resist project could include wax, various brushes, and sponges; foam rollers and a piece of chamois on a stick (which is basically a faux-finishing tool) are also useful.

FREEHAND

For your first project, you might want to do something easy, like the abstract design

Clockwise from top left: *Painting an abstract design with an inexpensive brush on stretched white silk; overpaint. Here, Michelle uses Dye-Nu-Flow in a taupe color. After adding more wax, she overpaints again in a darker tone.*

Michelle painted on white silk in the example shown on this page (see p. 88 for several finished variations). Dip a chip brush into hot wax and paint swirls onto the fabric. The wax goes on clear, quickly dries,

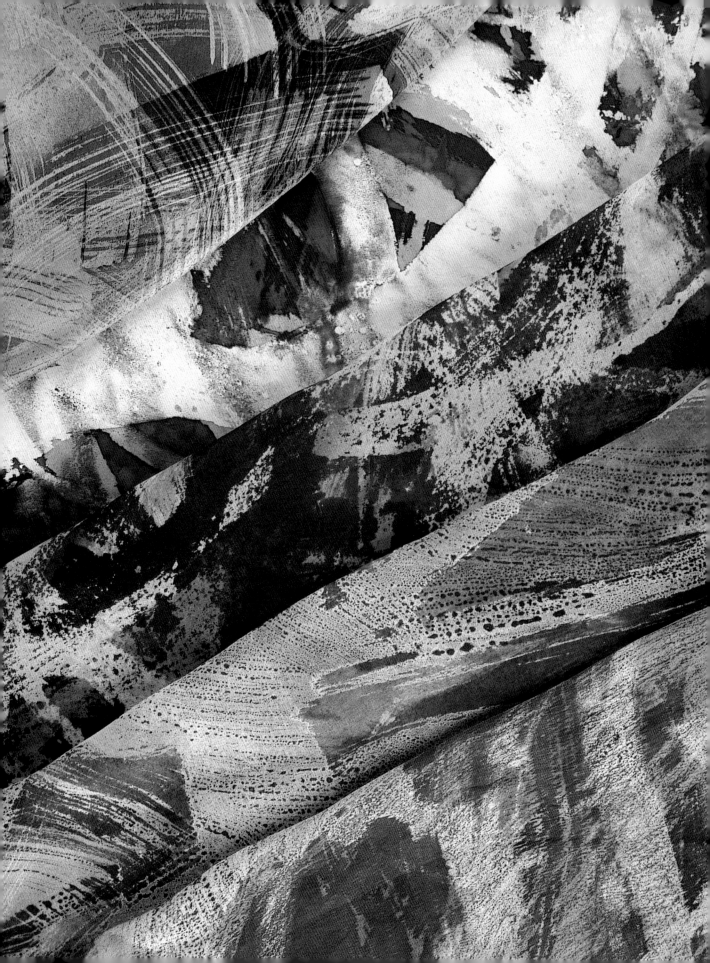

and appears translucent. If the wax is white when you paint it on, it is not hot enough and has not penetrated the fabric.

When the wax is dry, overpaint the fabric, using a light to medium color. Any of the dyes or fabric paints we talked about in Chapter 1 will work (except acrylic). Whichever you choose, let it dry completely at this step.

Repeat these steps. Paint on more wax, let it dry, and overpaint with a darker color.

STAMPING

Stamping with wax gives you the option of more detailed repeat figures. Choose a big bold stamp—nothing with detail or filigree. Dip the stamp into the hot wax, and press it onto the fabric. As you'll notice in the photo, Michelle holds a folded paper towel (sometimes she'll reach for a plastic lid) beneath the stamp as she moves it from the wax pot to the desired position on the fabric, a silk that she has previously dyed the palest blue. You'll need to work fairly quickly so the wax does not

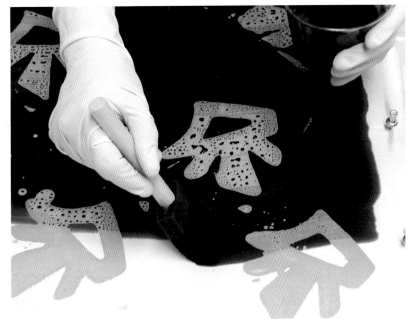

Opposite: *Michelle has painted this same abstract design in many color variations.*

Right, above: *Printing on dyed silk with a handmade stamp.*

Right, below: *Overpainting the wax-stamped fabric with dye and a foam brush.*

begin to dry on the stamp.

After the wax has dried, use a big brush (Michelle is working with a foam brush) to overpaint. Go right over the waxed areas. Notice the big blotchy sections, which are intentional. They will result in more texture and surface interest. Let the paint dry.

TJANTING TOOL

A traditional batik tool, the *tjanting* (pronounced "chanting") tool consists, as we've mentioned earlier, of a metal vessel with a pouring spout, which is attached to a

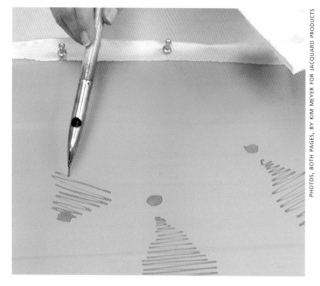

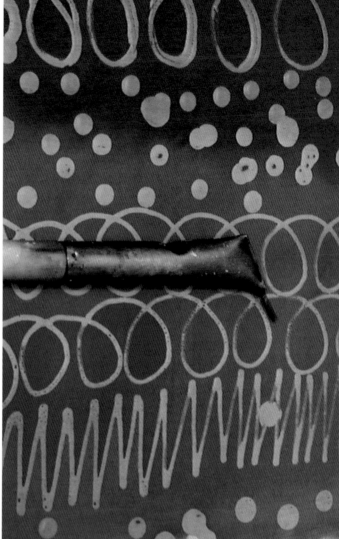

PHOTOS, BOTH PAGES, BY KIM MEYER FOR JACQUARD PRODUCTS

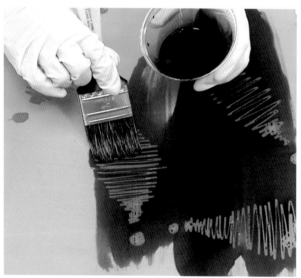

Above top: *The traditional* tjanting *tool allows you to apply thin lines of wax.*

Above: *Overpainting the waxed fabric using a large brush and dark blue dye.*

Above right: *A few of the effects you can achieve by using a* tjanting *tool.*

wooden handle. The metal keeps the wax hot, the spout facilitates pouring, and the handle protects your hand from the heat and gives you control over the line. Let the tool heat up in the wax before using it. Use it when you want really fine lines in a spontaneous design or for meticulous outlining and detail. In the top left photo, Michelle applies wax to a previously painted length of silk.

Once the wax has dried, you can overpaint (see above).

COLORING BOOK

Although not at all difficult, the "coloring book" method requires the most control and attention of any of the resist methods we've talked about so far. It comes closest in that regard to traditional silk painting, but there is still a great degree of freedom involved with this technique.

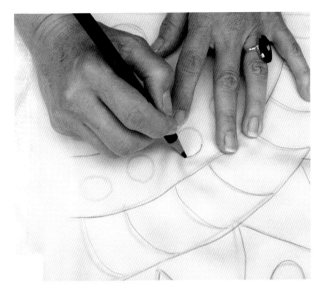
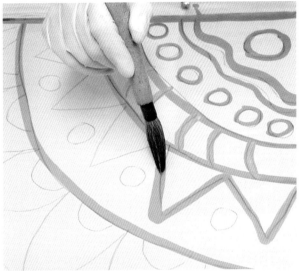
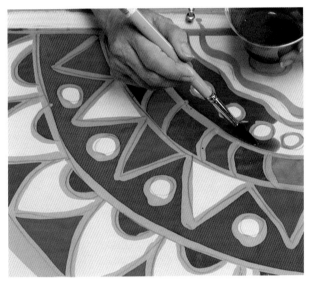
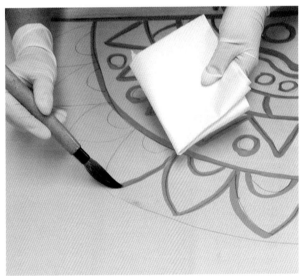

Stretch the fabric in a frame. Draw or trace your design, actual size, with a marker on a piece of paper. Lay fabric over the design and trace it onto the fabric with a pencil, or use a wash-out or fade-away pencil or marker.

Set your wax pot near the stretched fabric. Use a Chinese-wax bamboo brush with a pointed tip to go over the lines of the design. Make sure that the lines of wax are continuous and unbroken. This is crucial. They will serve later to hold dyes where you want them, and a broken or too-thin line of wax will allow dye to run into undesired areas. Hold the fabric up to the light to make sure the lines of wax are strong and unbroken. If you see even the tiniest gap, go back in carefully and patch the area with more wax.

Clockwise from top left: Trace the design onto the fabric; "paint" over the traced lines with a bamboo brush and hot wax; protect the design by holding a paper towel beneath the brush; color in the design.

Hold your paper towel underneath the wax brush as you move it across the fabric.

When the wax has dried, fill in the design with paint or dye. Just touch the tip of the brush

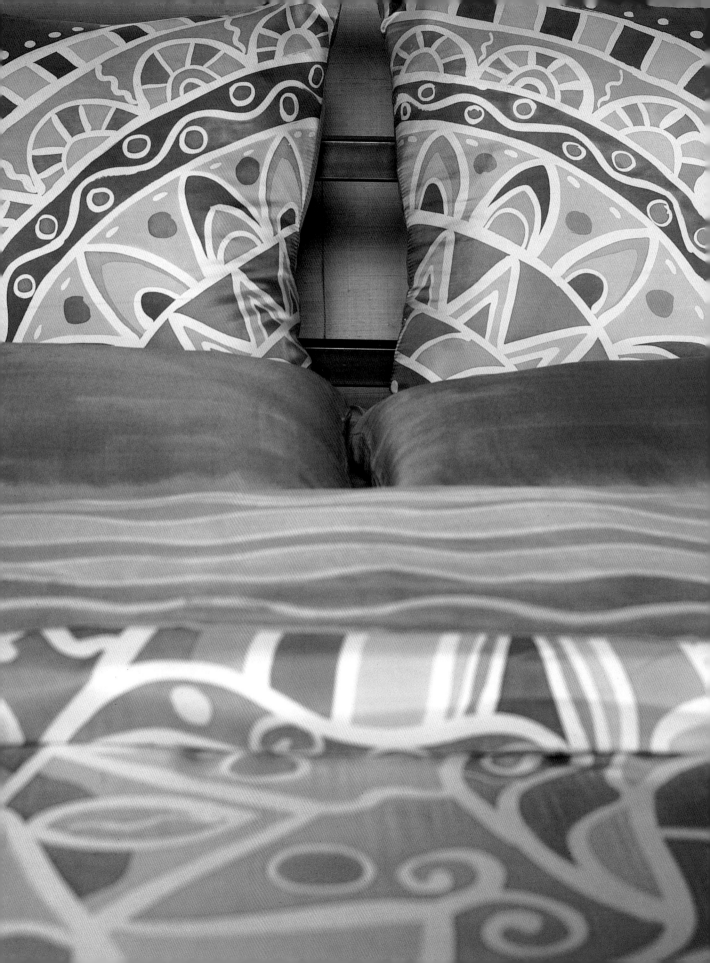

PHOTOS THIS PAGE BY KIM MEYER FOR JACQUARD PRODUCTS

Opposite: The design for this bedding ensemble was done with the coloring book technique.

Above right: Michelle applies big strokes of cold-water wax to the pile side of celadon velvet.

Below right: Overpainting the fabric with a chocolate brown dye. Notice how dye goes over resisted areas, too.

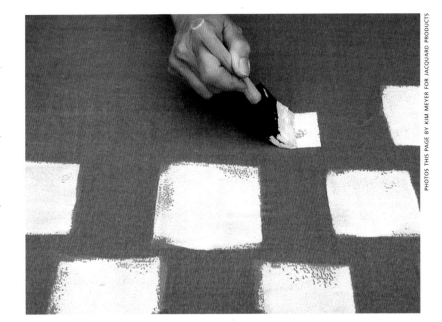

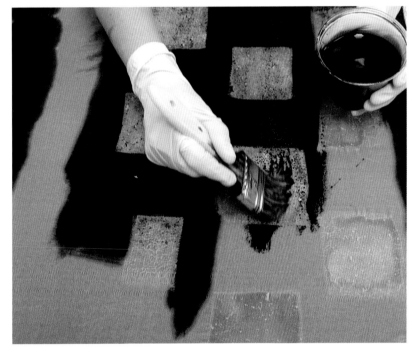

to the silk, and the paint or dye will flow onto the fabric. It's a capillary action; very little effort is required.

If you should get paint in the wrong place, you can correct the mistake by immediately blotting up the paint with a cotton swab soaked in water. This flushes and dilutes the dye. Alternate with a dry swab, then another wet one. This dilutes the color and flushes it from the silk. Scrub the fabric and work quickly and carefully. Avoid getting water onto other painted areas. Let the repaired area dry before repainting.

OTHER RESISTS

You can also use cold-water wax as a resist, as well as potato starch, sugar syrup, gutta (or gutta-percha, a latex-like subtance), and other products. (Because potters also use cold-water wax, you can find it at ceramic supply houses and dye suppliers.) Michelle here applies cold-water wax on celadon velvet in a geometric pattern. In an exception to the usual rule of applying resist and dye to the smooth side of velvet or velveteen, she works here on the nap side of the fabric. Whenever you want a lot of visible texture when waxing velvet this way, work with the nap side up. Foam brushes work well for this.

After the wax is dry, overpaint with a big brush. Paint over the waxed areas, not around them, to get a highly textural effect.

STEAMING

As is the case with all the methods we've discussed so far (freehand, stamping, coloring book, or whatever else you may use), you need to remove the wax and set the dyes with steam.

Unless you're dealing with velvet or velveteen, ironing is the first step in the steaming process. Cover the fabric with a layer of kraft (sturdy brown) paper or clean newsprint (or paper towels for small projects). Using an old iron, iron over the fabric to transfer the wax to the paper (see photo below, top left). Discard the used paper and replace it with clean paper as often as you need to. Remove as much of the wax as you can by ironing.

Now it's time for steaming. Lay the fabric on a sheet of clean newsprint or muslin and roll it up loosely (see photo below, top right).

Flatten the roll, then coil it up into a loose bundle. Tape the roll together (see photos below, lower right and left).

Then wrap the taped bundle in foil (see top photo on p. 95.)

Prepare a large kettle for steaming. Place a canning rack or sturdy stoneware mugs in the bottom (see photo on p. 95,

Clockwise from upper left: *Remove wax by ironing on absorbent paper; roll fabric on clean paper or muslin; flatten roll and coil it up; then tape the roll together.*

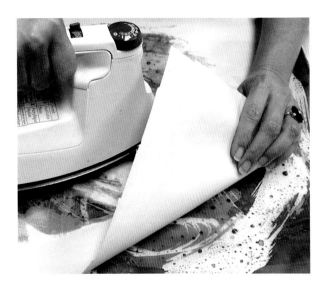
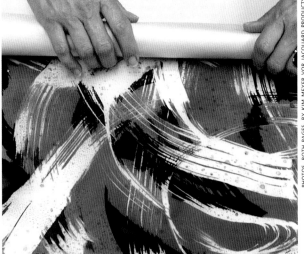

lower right), or devise a similar way to elevate the foil-wrapped packet. Pour about 2 or 3 inches of water into the kettle. The water *should not* come into contact with the bundle containing the fabric.

Now place a folded towel over the kettle and, over that, a folded section of newspaper for protection from condensation (see photo below, lower left). Finally, set the lid on top. Set on heat and steam for 30 to 45 minutes.

After steaming, immediately remove the fabric from the wrappings. Let the fabric air-dry for at least 24 hours. Have the piece dry-cleaned to get rid of every last trace of wax residue, then wash it.

Gradually put the fabric in cold water; a lot of dye will be released. Wear rubber gloves, and move the fabric about in the water—don't let it just sit there. Begin adding warm water and, gradually, hot water.

Let all the water run out of the sink or other vessel and remove the fabric. Fill it again with cool water, and add Synthrapol, Ivory Liquid, or similar mild detergent. Put the fabric back in and keep it moving. By this time, most of the dye will have been washed out, and the water will be getting clearer. Increase the temperature again gradually. When the water becomes clear, or almost clear, toss the fabric into the washer on the gentle cycle with the temperature set to cold or medium with more detergent.

Keep similar colors together—blues and greens together would be all right, but not reds and greens. Repeat on the gentle cycle with warmer water, then put the fabric into the dryer. Remove silk while it is still damp and iron it immediately. Let velvets dry completely. Now your dyed fabric is pre-shrunk, prewashed, and ready to go.

Clockwise from upper left: *Wrap coiled bundle in foil; place bundle in steamer; cover with towel, newspaper, and the lid of the steaming pot.*

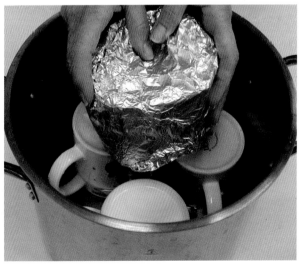

SAMPLER SCARF

One of the many delights of working with wax resist is seeing the finished effect after the wax has been removed. No matter how carefully you plan or how carefully you work, there are always surprises. Don't worry: The nature of this technique lends itself perfectly to the unexpected—to serendipity. The hand of the artist comes through. Let's make a sampler scarf so you'll have a chance to play with some tools and materials and see for yourself that wax resist is as much fun as we say it is.

Gather these materials:

purchased hemmed silk scarf
fabric dye, fairly dark, one or two colors
paraffin and beeswax
electric skillet or double boiler
several wax applicators
freezer paper
brown kraft paper or newsprint
iron
steaming set-up (described on page 95)

Let's go! Prewash the scarf, even it's from a company that caters to dyers and is labeled PFD, or prepared for dyeing. It could still have some remaining oils or other impurities that

Above: *Roll on wax with a roller sponge.*

Opposite: *Continue adding lines of wax, using different applicators.*

might affect the dyeing. Iron it dry, then iron it to the freezer paper to stabilize it. In the sample you see here, the scarf is pale blue; you can order scarves in a particular color or dye or paint it beforehand.

Arrange your working area, with the wax pot next to the scarf for ease and efficiency.

Apply the first horizontal rows of wax. Michelle has used a roller sponge that creates three stripes with one pass.

Go on to your next tool and make more rows. Because you're working on a light-colored fabric and the wax dries white so quickly, you won't be able to tell much at this point about the finished

effect. Don't worry about that; just keep "painting" wax onto the silk, using and re-using as many tools as you like. In the photos opposite (page 97), Michelle is applying wax with a segmented bristle brush, a sponge, and a faux-finish chamois tool. You might choose completely different applicators for your project.

For a controlled spatter-effect, cover part of the scarf with paper to mask and protect areas you don't want spattered. Hold one clean brush in place, then cross a wax-dipped brush over it at an angle as shown (see top photo, p. 98). Tap the top brush gently against the lower brush to spatter wax in a manageable pattern and location. Repeat as needed. This technique creates an interesting surface texture.

While wax dries on the scarf, unplug the wax pot and put the tools away for future use. They'll be soaked with wax, which you won't be able to remove, so just consider them dedicated to wax work—rather than ruined!

Overpaint with fabric dye, using a large brush. Paint right over the waxed areas for a nice textured effect.

PHOTOS, BOTH PAGES, BY KIM MEYER FOR JACQUARD PRODUCTS

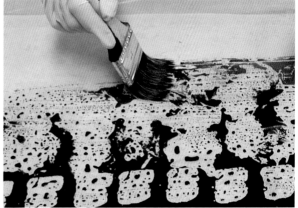

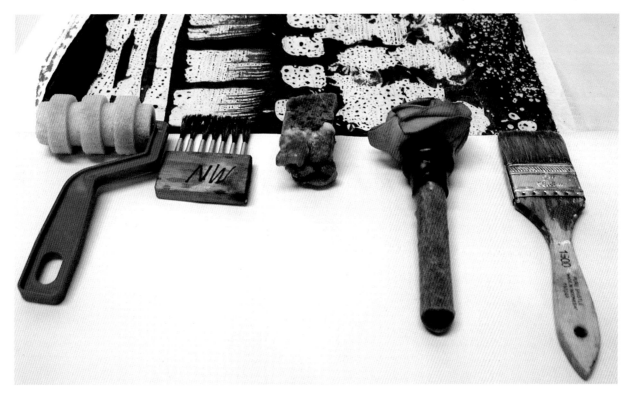

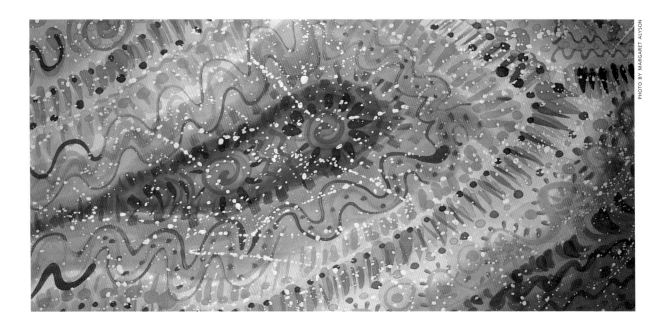

PHOTO BY MARGARET ALYSON

PHOTO THIS PAGE AND OPPOSITE BY PETER GONZALEZ

Above: *This extravagant multicolored scarf shows the starry effect of spattered wax.*

Left: *This dramatic "dress" is actually the Sampler Scarf shown in progress on pages 96 and 97.*

Opposite: *Michelle began by scrunch-dyeing velvet a tangerine color. She then applied wax resist and overpainted with Jacquard Red Label dyes.*

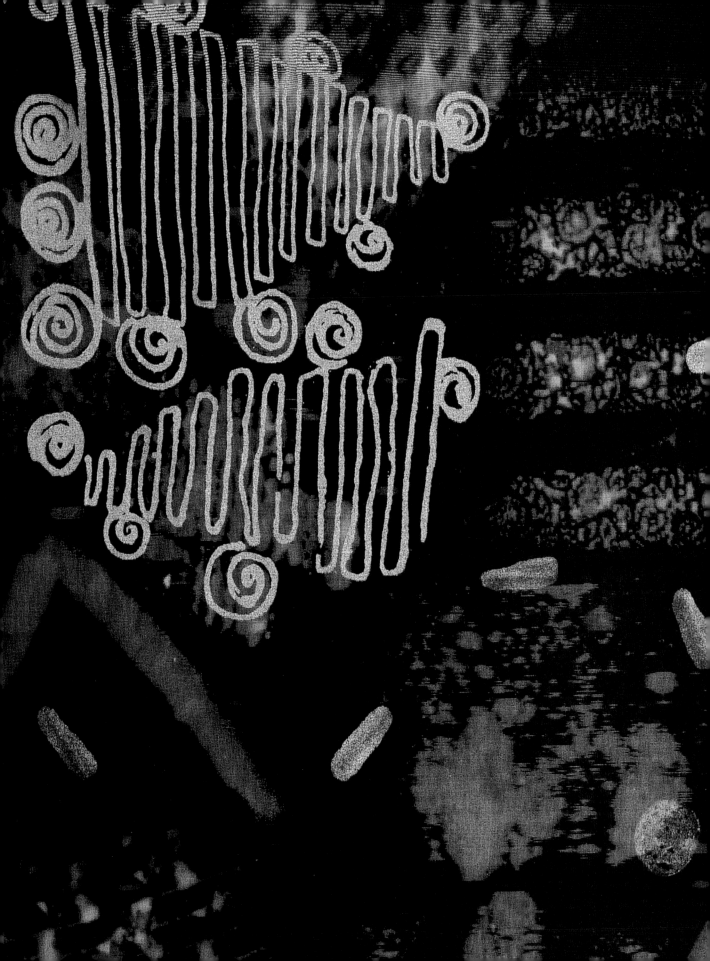

PHOTO BY PETER GONZALEZ

SPECIAL EFFECTS

*A*rtists, like scientists, are always experi-
menting and asking "What if?" What if I
took this fabric outside, hung it on the line,
and sprayed it with dye in a water pistol? What
if I dipped a stamp in bleach, discharged black
velvet, and then colored it in with fabric markers?

We don't need *special effects;* we could
entertain ourselves for a long time with basic
paints and dyes. But special effects are fun. Here
are several techniques that Michelle incorporates
into her work on occasion. Some are familiar —
like sprinkling salt onto dyed fabric while it's
still wet—and others might surprise you.

SALT

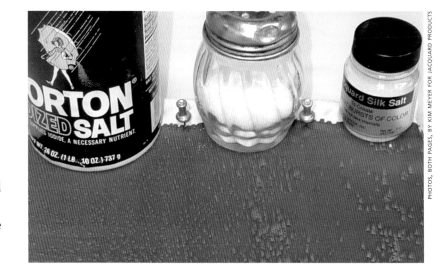

Sprinkling salt onto just-dyed fabric causes the dye to move toward the salt, making natural organic patterns. When salt encounters dye, it absorbs it and pulls the dye into its crystals. The patterns produced after the silk has dried make you think of water, ferns, or the Milky Way galaxy. Traditional silk painters, working with representational motifs and gutta resist for carefully controlled effects, have long delighted in spicing up their work by using salt. While it does offer refreshing contrast to precise designs, the salt technique works equally well in spontaneous applications.

You can use any type of salt—regular table salt, Kosher salt, rock salt, pickling salt, and salt formulated for silk dyers. The different sizes of the crystals will yield varied patterns. The technique works best with darker tones on smooth fabric.

Stretch the silk with pins or iron it to freezer paper.

Brush the dye generously onto silk to create a fairly even field of color.

Immediately, before the dye can begin to dry, sprinkle salt onto the wet silk. In this example, Michelle is doing a "sampler" with various kinds of salt. She applies each in a long stripe. Do not oversalt. Part of the beauty of this technique is

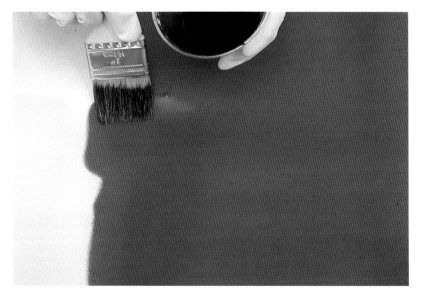

its variation, so don't cover a surface too evenly or heavily.

Let the fabric sit undisturbed while it dries completely.

Depending on how wet the fabric was and how much salt was applied, a little or a lot of the salt will brush off easily. You may need to lightly scrape across the surface of the fabric with a coarse stencil brush or a credit card to remove more of the salt. Get as much salt off the fabric as you can before

Top: *Each kind of salt works a little differently under the same conditions.*

Above: *Paint an even field of dye onto stretched silk.*

setting the dye. If you are ironing to set the dye, iron over the salted areas on the wrong side of the fabric. It will feel stiff at this point, but once the dye is set, you can wash the silk gently and remove the last traces.

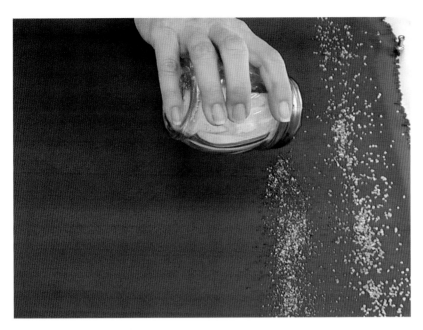

If you are steaming, use more layers of absorbent paper, as the salt residue will attract the moisture.

For even more dramatic effect with areas of high contrast, begin with scrunch-dyeing, leaving low areas where dye will pool. Apply a coarse salt.

Left: *For a sampler, apply different types of salt in stripes.*

Below: *Subtle, unpredictable patterns are formed when salt works its magic on dyed fabric.*

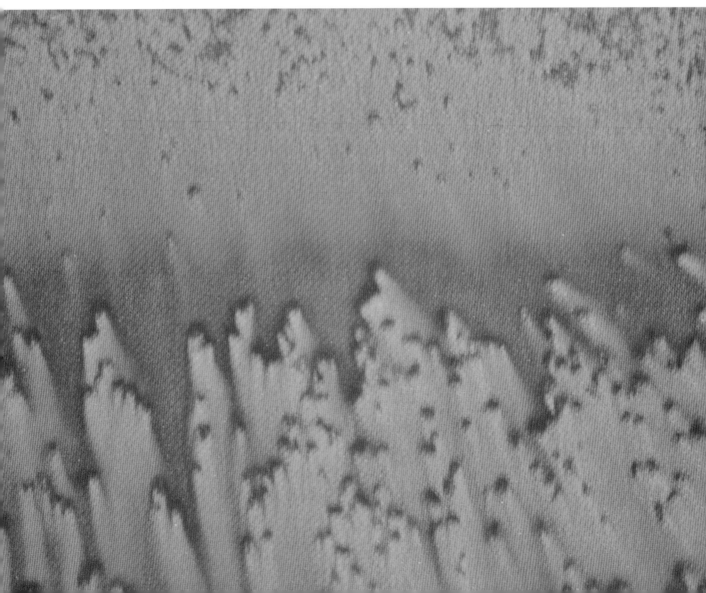

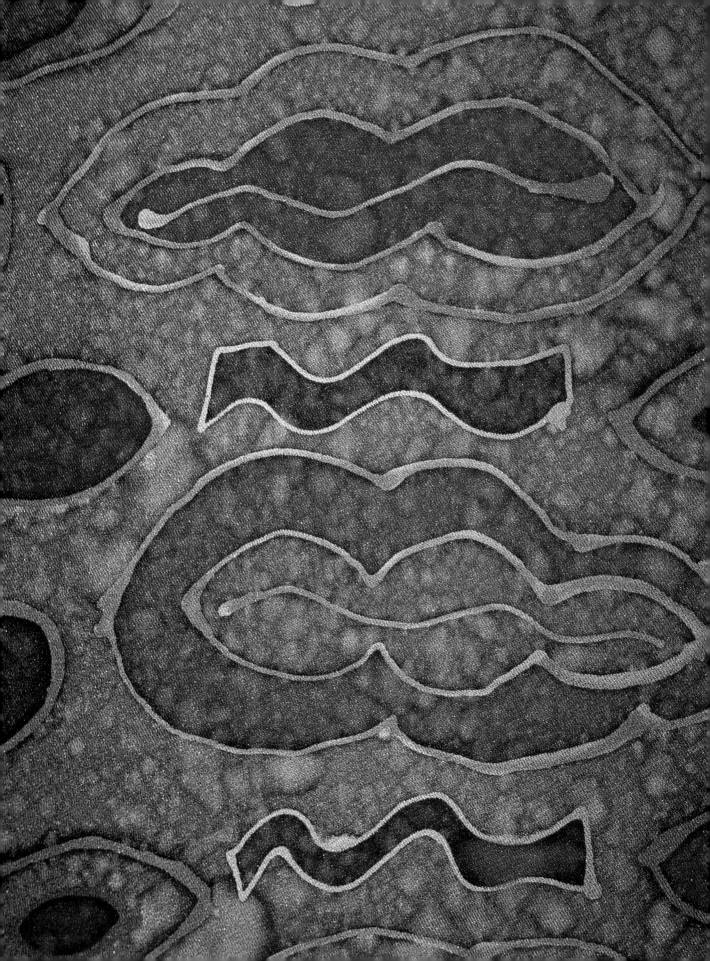

ALCOHOL

Like salt, applying alcohol to wet dye creates an irregular pattern. If it is applied to dry fabric after dyeing, it softens the dye, much like watercolor paint applied to wet paper will soften and spread. We are interested here, however, in the power of alcohol to create accents—to add highlights and definition—rather than an allover effect. It is worth noting, though, that a cotton swab dipped in alcohol can be used as an "eraser" to blur and soften irregularities and errors—to "lift" the color.

Stretch the fabric and paint your design. To create the pattern of green leaves against a crimson background, Michelle used Red Label, a fiber-reactive dye. You can experiment with other dyes and paints. (In fact, alcohol applied to acrylic paints on wood or other smooth surfaces produces a similar intriguing effect.)

Using a cotton swab, Michelle "paints" the veins of a leaf with undiluted household (rubbing/isopropyl) alcohol.

To another leaf motif, she adds dots in the same fashion.

The finished effect, which would be impossible to achieve

Opposite: *This Persian-inspired border gets added mystery, an aged effect, from drops of alcohol randomly sprinkled on its surface.*

Below: *For a watercolor effect, "paint" leaf veins with alcohol. To some leaves, Michelle adds dots with alcohol.*

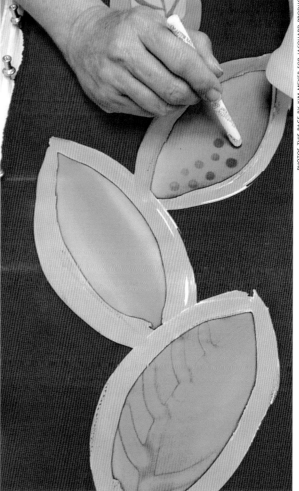

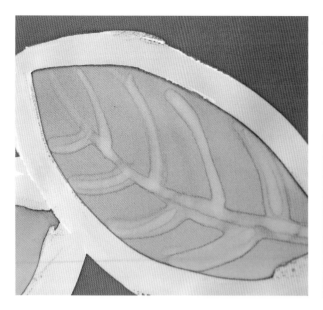

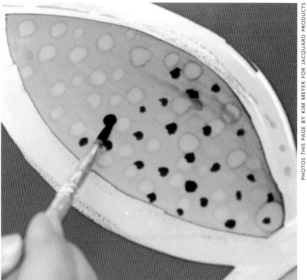

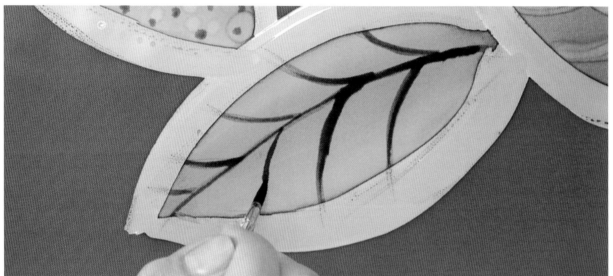

PHOTOS THIS PAGE BY KIM MEYER FOR JACQUARD PRODUCTS

Top left: *Lines blur and lighten when alcohol is applied to dyed silk.*

Top right and above: *To some leaves, Michelle adds darker dots, to some, darker veins.*

with an added layer of paint or dye, is very painterly.

After the alcohol-dotted leaf has dried, Michelle comes back in with paint or dye and adds darker dots as a counterpoint (see above photo).

She paints darkened veins onto some leaves for even more depth and interest.

SHORTCUT SHIBORI

Shibori, an ancient Japanese fabric dyeing technique, is very popular among fiber artists. It involves compressing fabric to create resists. When the fabric is immersed in dye, patterns result. The tie-dyes of the sixties are a form of *shibori*, often producing sunbursts and concentric circles. Many traditional *shibori* techniques, however, result in irregular stripes. The "shortcut" version that we discuss mimics this type of *shibori*.

Opposite: *A velvet coverlet in aquatic blues, shortcut* shibori..

Below left: *For shortcut* shibori, *begin by dissolving soda ash in water.*

Below right: *After soaking, twist fabric to remove as much water as you can.*

At first glance, you may say to yourself, "*This* is a shortcut?" But trust us— it is. Authentic *shibori* is quite time-consuming and complicated.

You'll need soda ash, which is a white powdered substance available from dye suppliers, and heavy plastic sheets in addition to your basic supplies.

Dissolve one cup of soda ash in a gallon of water. Here, Michelle is using a plastic shoe box for a container.

Soak the fabric (velvet, in this example) for ten minutes or so, then remove it from the water and wring out the excess.

Lay the fabric on a plastic drop cloth. If you're working

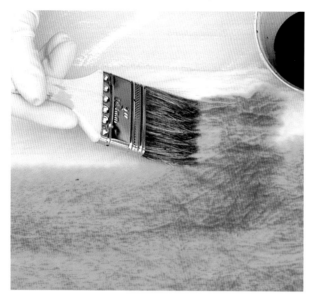

PHOTOS THIS PAGE BY KIM MEYER FOR JACQUARD PRODUCTS

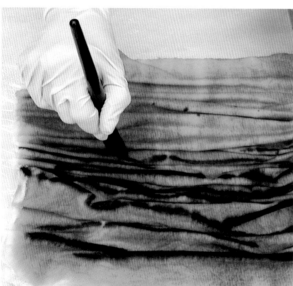

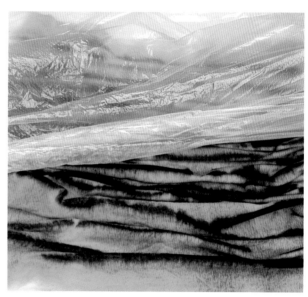

with velvet, place it smooth side up, pile side down. Apply liquid dye in a light to medium tone, using a large brush.

With gloved hands, accordion-pleat the dyed wet fabric.

Dip a pointed watercolor-type brush into a darker color of dye and overpaint the raised areas—the folded edges. Don't worry if some of the dye gets on the flat areas; shibori allows plenty of room for unintentional effects.

Cover the wet fabric with another layer of heavy plastic and tuck the ends under. Let it sit overnight. This is known as "batching" and allows the soda ash and the dye to chemically bond with the fabric.

After letting it sit (or batch), rinse the fabric out and machine-wash it. The finished fabric will have subtle stripes and gradations.

Top: *Cover damp fabric with an even field of dye. Loosely pleat the fabric.*

Bottom: *Brush darker dye onto the peaks of the pleats for contrast. Cover with heavy plastic to batch.*

Opposite: *This close-up of the coverlet on p. 107 shows its stripes, beaded fringe, and sponge-painted silk lining.*

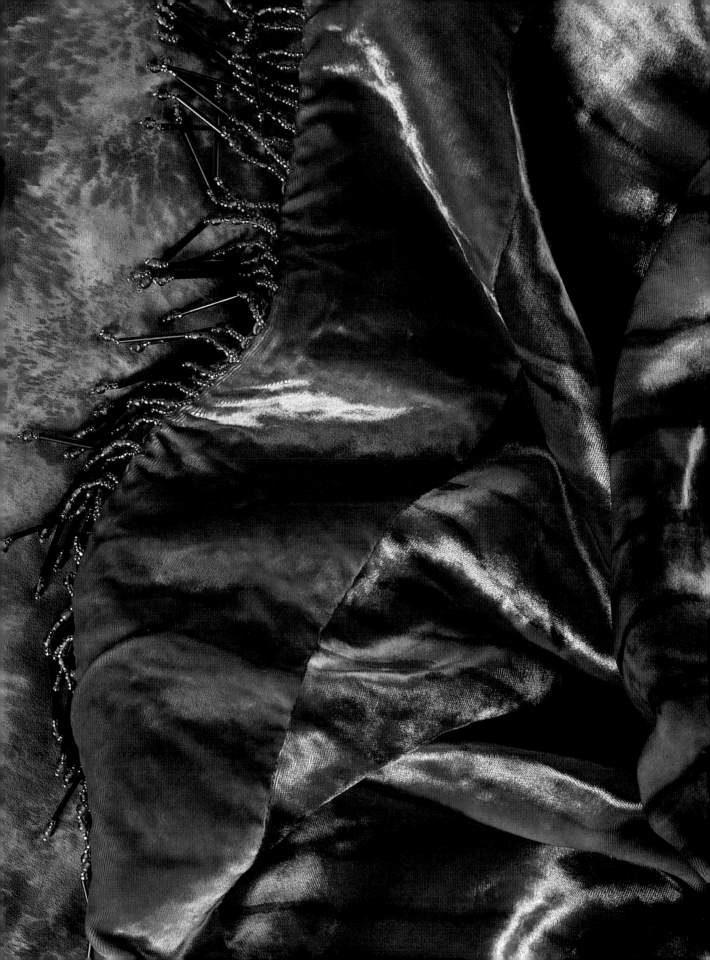

HIDDEN OBJECT

This little trick is very much like a rubbing, which involves placing a piece of paper or fabric over a raised or embossed surface and rubbing a crayon or pencil over the paper or fabric so that the raised pattern on the underlying surface comes through. In this version, textile paint or thickened dye is applied to fabric that has been placed over an actual object.

Below left: *Place fabric over an object and sponge on a little paint.*

Below right: *A raised brass figure on cotton velveteen.*

Opposite: *Colors catch the light in a whole new way when silk is heavily pleated.*

For this project, Michelle has chosen ordinary scissors as her hidden object.

Lay fabric over the scissors or other object. Pour a small amount of paint or thickened dye into a paper plate or other palette. Dip a sponge or Spouncer into the paint, remove the excess, and dab over the object. This works best with a nearly dry applicator. If you use too much paint, you lose the crisp edges and definition of the object.

Experiment with any textured object flat enough to hold in place while applying the paint or dye. You can achieve photorealistic effects because you are indeed reproducing the image of the actual object. Or make an overall design by dry-brushing over corrugated cardboard, bubble wrap, heavy lace, or carpeting.

The central motif of the colorful design on cotton velveteen below could have been painted freehand. It was, however, a hidden object—a Mexican *milagro* (an embossed metal image) of a woman's torso. After using this technique to "copy" it onto the velveteen, Michelle surrounded it with monoprinted motifs.

FORTUNY PLEATING

Ancient Egyptians pleated whisper-thin cottons, and Navajo women wrapped their voluminous skirts around a broomstick to make pleats. One of Michelle's inspirations is the 1920s Venetian designer Mariano Fortuny, famous for

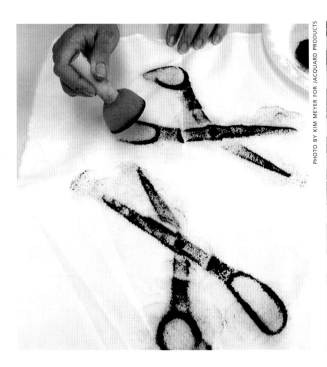

PHOTO BY KIM MEYER FOR JACQUARD PRODUCTS

PHOTO BY MARGARET ALLYSON

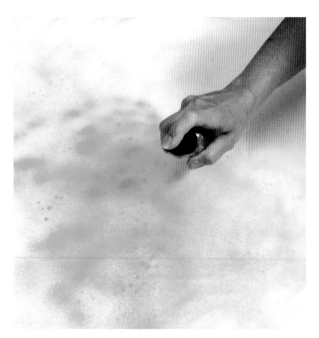

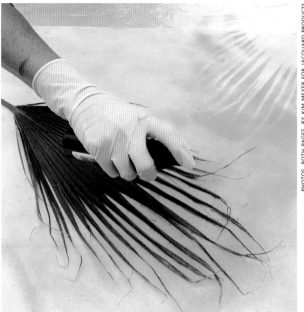

PHOTOS, BOTH PAGES, BY KIM MEYER FOR JACQUARD PRODUCTS

Above left: *Spray white or pale-colored silk lightly with diluted dye.*

Above right: *Lay leaves or other objects down on sprayed background. Spray again with darker dye.*

his pleated silks. This technique is named in his honor, but is not intended as an authentic explanation for the methods of that great master.

Begin by hemming, by hand or machine, a large (2 to 2½ yards long and 36 to 55 inches wide) piece of silk—China silk, charmeuse, or crepe de chine. Paint or dye it, using any of the techniques you've read about so far. Steam, iron, or heat-set the dye or paint.

To add another dimension, add texture. Here's how.

Spray scarf with water to dampen. Enlist a helper, if possible, for the pleating process.

Or use a big strong clip attached to a sturdy hook to hold one end. Begin twisting one end. Keep twisting until the scarf doubles back on itself like a pretzel. Have your helper grasp it at the doubled-back point. When you cannot twist it any more, secure the tightly twisted silk with large rubber bands. Stuff into a knee-high stocking and hang outdoors to dry—or put it in a home dryer with a couple of big towels.

Let dry completely before you remove the rubber bands and open up the scarf. Be patient, even though you will be tempted to peek.

FAUX AIRBRUSH

Airbrushing—the process of forcing air through a small amount of paint to produce a thin mist—delivers subtle gradations of tone and color. Michelle's version provides instant gratification. Although the example we show is monochromatic, there is no reason you couldn't use several colors.

Work outside. Hang light-colored fabric up on a clothesline or stretch it flat on sawhorses. Dilute Dye-Na-Flow or other dye or paint with water (how much is up to you) in a spray bottle.

Spray fabric lightly with diluted dye. Add a little more dye; spray again. Continue adding dye if you like, working from pale to dark shades.

Now, lay a flat object (like a large leaf) on a light-colored area of the background. Spray with a darker tone of dye. Move the leaf, and repeat as often as you like. Shifting the leaf creates a random pattern.

BASTING

The mottled effect you will get from applying dye or paint with a turkey baster is wonderfully bold and random.

Lay fabric on a flat surface and apply diluted dye or paint with the turkey baster, leaving areas uncolored. Come back with a darker tone and fill in uncolored areas. The tones will blend.

With gloved hands, gather up the fabric in a loose accordion fold.

Scrunch together as tightly as you can to blend colors.

Set by ironing or steaming.

Top left: Draw a medium- or light-toned dye into a turkey baster and apply to fabric. Right: Go back in with a darker shade of the same color.

Bottom left: Gather up fabric into a loose fold. Wear gloves to protect your hands. Right: Squeeze fabric tightly to remove excess dye and to make sure there is no white (or background) remaining.

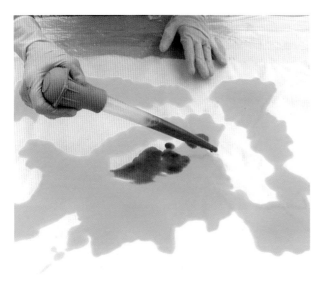

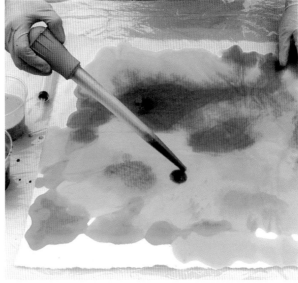

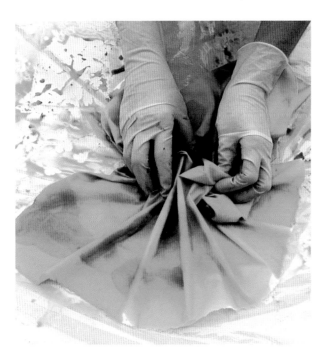

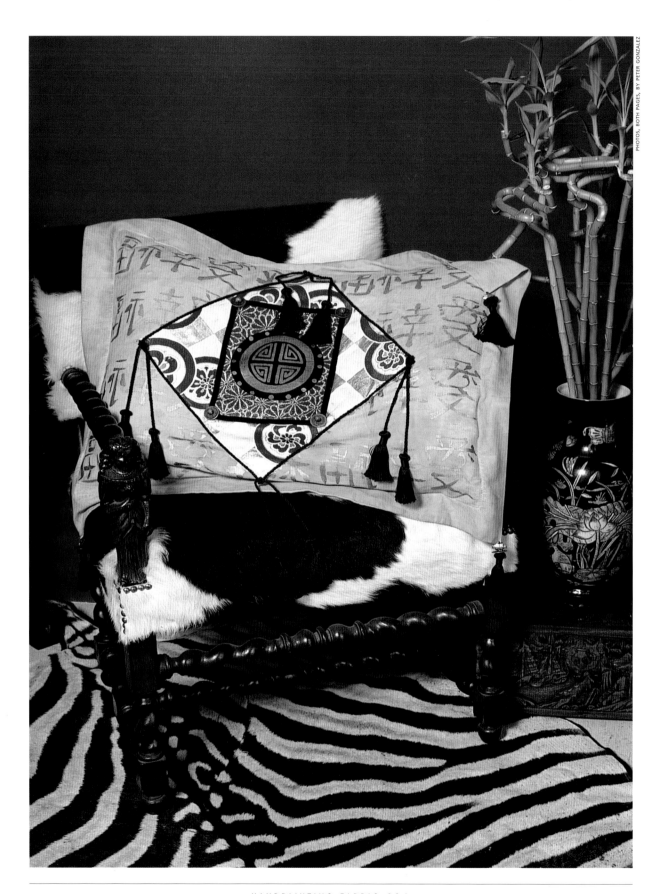

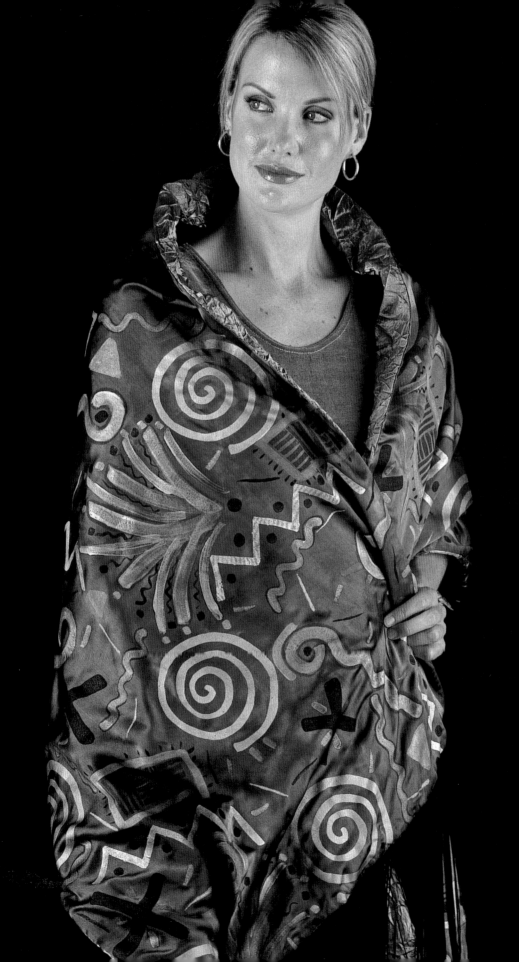

LAYERING

We've now covered a couple dozen techniques. And the beauty of it all is that you can combine them. You don't have to stop layering until you are perfectly happy. Layer as many or as few as you like. Simplicity is elegant, and over-the-top is exciting. It would be quite possible to begin with a piece of white silk and do the following: immersion-dye, sponge, freehand-paint, discharge, overdye, stamp, stencil, and silkscreen. Then you could add beads, pleats, and tassels. That would definitely fall into the over-the-top column, but you could do it.

As contemporary painter Audrey Flack has remarked, "As in filling a glass drop by drop, when the glass is full, it takes only one extra drop to cause a spill, one less to create perfection." We think a textile artist has a little more leeway than a photorealistic painter, but her words ring true.

We have seen some pieces of fabric that were overworked, but as a rule, right up to the point where holes appear or the textile becomes board-like, layering adds richness. In fact, we've seen fabrics go past both those points and still be successful works of art.

There are other techniques beyond the scope of this book: applying a chemical that burns away part of the fabric; applying metallic foils; actually burning the fabric; tucking; smocking; gluing; and sewing on ornamentation. Each new skill offers a new way to layer.

In the two photos below, Michelle is working on silk that she has previously scrunch-dyed. She overstamps with handmade stamps, prints, and adds freehand accents in metallic paint. (See the finished piece on p. 115.)

Below: *Michelle overstamps and free-hand paints a piece of scrunch-dyed silk.*

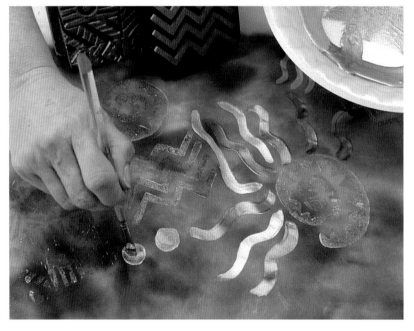

PHOTOS THIS PAGE BY KIM MEYER FOR JACQUARD PRODUCTS

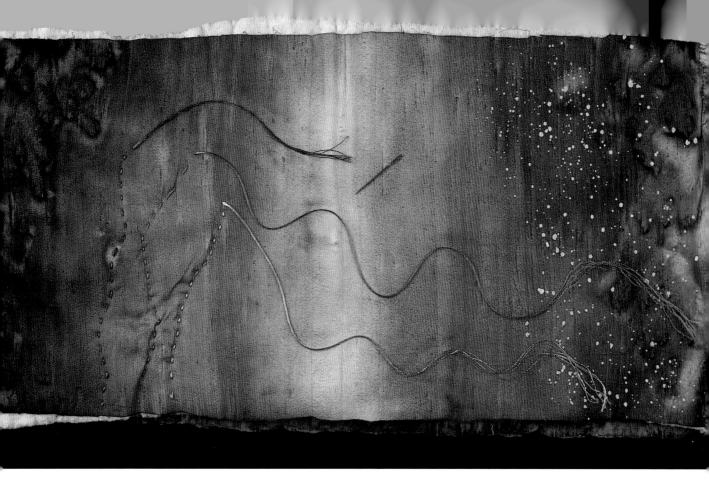

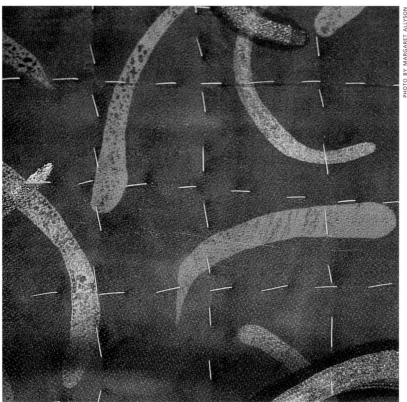

Above: *After photographing a Taos sunset, Michelle began this work in progress. She dampened douppioni silk and painted it with Dye-Na-Flow in an ombré of dark periwinkle, violet, magenta, orange, and yellow. When dry, it was spattered with diluted gold Lumiere paint.*

Left: *After dyeing, doing wax resist, foiling, and overpainting with metallics, Michelle has basted this piece in preparation for subsequent quilting.*

Preceding spread: *Pillow—from the center out, a circle of black silk handpainted in metallics, a red rectangle cut from a vintage obi, a large piece of silk turkey-baster-dyed with Dye-Na-Flow in shades of green. Shawl—scrunch-dyeing, handpainting, and silkscreening layered to produce a rich texture in this shawl, "Slipping into Darkness."*

Above: *The pattern of water lilies is exuberant and, cautions Michelle, "not for beginners." After handpainting the elaborate blossoms, leaves, and background, she added accents when the silk had dried. The professionally done ¼-inch channel quilting sets up a secondary pattern, like ripples in fast-moving water.*

QUILTING

We've just seen a layered piece ready for quilting. Like pleating, quilting adds another actual texture to a flat length of fabric.

Quilting can be done by hand or machine; you can do it yourself or send it out for even, allover channel stitching that would take a long time to do on your own sewing machine.

American designer Mary McFadden made this a classic look in couture collections. Layer a piece of batting between your embellished fabric and a lining material. Pin, and then baste to hold the layers together. Quilt as desired. Just a few hand stitches here and there can make a noticeable difference.

Left: *This delicate floral motif on a deep black background would have been exciting on its own—but note how the outline quilting, done by hand, further emphasizes the design. The lilies now seem almost to float.*

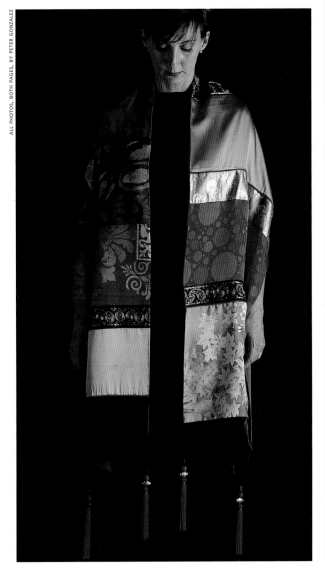

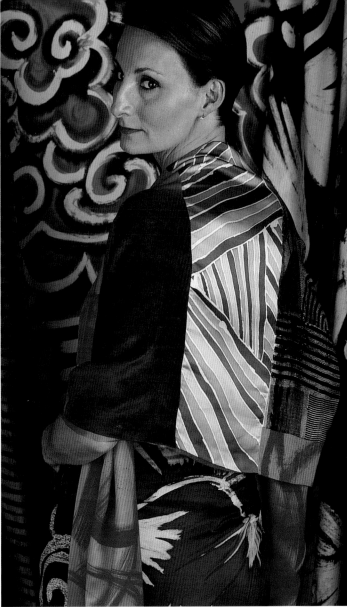

COLLAGE

Not only can we layer dye, bleach, wax, paint, and other substances onto our fabric, we can go a step further and combine separate textiles into a single piece. Generally, and especially for wearables, this is accomplished by sewing. However, there is no reason you cannot experiment with—and even produce a wall-hanging or accent piece by—using a hot glue gun, fabric glue, fusibles, or whatever comes into your mind to hold layers of fabric together. You could even use grommets or Velcro.

This is an excellent way to utilize (and show off) your precious scraps.

Collage can be preplanned. It can also add to your repertoire of strategies—you know, to address those design challenges and learning experiences we all love so well.

Above left: *Pieces of vintage obi are strip-pieced together with Michelle's custom fabrics for a one-of-a-kind silk shawl. Beaded tassels trim the ends.*

Above right: *Another long shawl made from strips of indigo-dyed silks. The limited palette is enlivened by occasional slashes of a deep sunset orange. Other indigos hang as background.*

PHOTO BY PETER GONZALEZ

THE POWER OF DETAILS

By now you've noticed that Michelle doesn't merely dye, paint, stamp, stencil, silkscreen, discharge, or otherwise embellish a piece of fabric. That's just the beginning. She pays very close attention to what happens next. If she makes a wearable, what sort of garment shape will best set off the fabric design? What trims, if any, should be added? Will the lining match, complement, or contrast?

FINISHING TOUCHES

On almost every page of this book so far, you've seen examples of Michelle's lavish use of fringe, cording, tassels, and beads. Some of these are relatively expensive, and some are straight from the flea market, garage sale, or thrift shop. After you've been handpainting fabrics for awhile and creating your own finished pieces, we predict that you'll join her on this search for the perfect finishing touches. Running out to the fabric store is going to yield a fairly predictable range of trims, unless you are extremely fortunate. It's so much more pleasant to open a drawer or a closet door and survey your own mini-collection. And when you can find an entire reel of braided trim at a flea market for a few dollars, having your own little personal store is a very real possibility.

You'll also learn to spot nifty fifty-cent necklaces that will yield lots of beaded accents, shredded vintage garments with unusual buttons and closures intact, and old lampshades with fabulous beaded fringe attached.

Part of the eclectic charm of these one-of-a-kind items is the carefree way you can mix and match Bakelite and coral, the serious and the tongue-in-cheek, and the cheap and the collectible. This is fun. There are no rules.

Let's look at some of Michelle's creations, paying close attention to detail.

Below: *This indigo-and-white silk kimono is a marvel of good design. Bold stripes provide counterpoints to the graceful, flowing lines. The extravagant obi gives it a shot of strong color, and a single tassel hanging from the back neckband sends the implicit message that nothing has been overlooked. Collection of Claire N. Golden.*

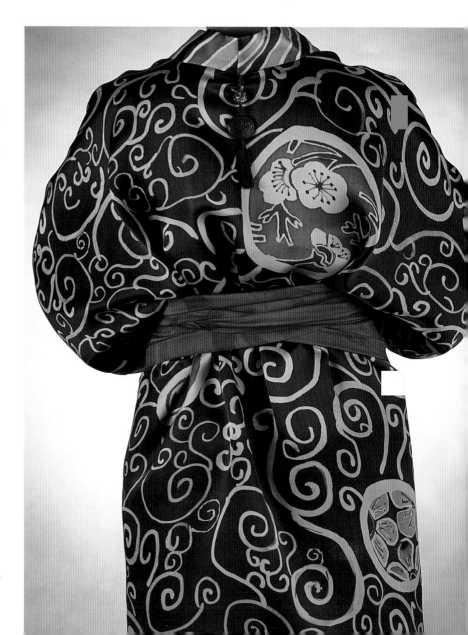

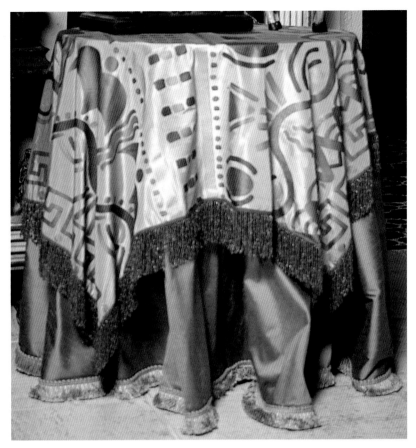

Left: *Michelle handpainted an exotic blend of Egyptian and art deco motifs onto silk taffeta for an opulent textile. Surrounding it with heavy beaded fringe does more than add visual snap and sizzle; the weight of the beads makes the cloth hang more heavily, adds an indefinable importance to it. Layered over an underskirt of more crunchy silk, edged with a simple metallic fringe, it is a priceless piece that could take center stage in any room.*

Below: *Primitive motifs freely hand-painted on cotton velveteen were pretty much guaranteed to make a bold statement. The finished pillow would have been exciting with a corded edge or fringed with leather strips. But the feather edging takes it to another level. Now it's not just for a tribesperson, it's for the chieftain!*

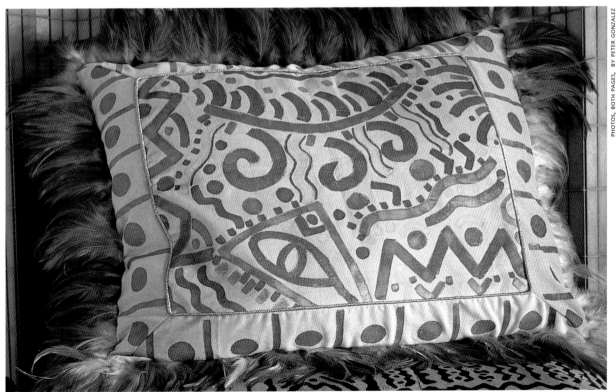

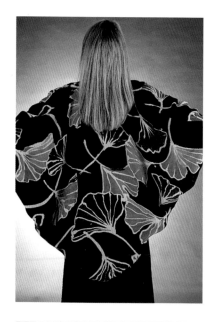

PHOTOS, BOTH PAGES, BY PETER GONZALEZ

Above: *Gigantic ginkgo leaves float across silk velvet with perfect grace.*

Right: *The front closure of the indigo jacket is finished with ombréd blue velvet, corded trim, and beaded tassels.*

Below: *Finishing off a collaged shawl is a band of silk brocade, black cording inset into the seam, and a beaded tassel. Notice the familiar red swirls on the orange silk.*

Opposite above: *A length of braided fabric forms the front band of the Monte Verde coat. Beads and trinkets and charms form individualistic tassels, adding physical weight, an audible jingle, and visual mystery.*

Opposite below: *This is a close-up look at the throw you saw in Chapter 8 in the discussion of shortcut shibori (p.108). It looks fabulous at a distance, and it's equally wonderful up close. Michelle lined it with a sponge-painted silk and edged it with beaded fringe in the colors of breaking waves.*

PHOTOS THIS PAGE BY PETER GONZALEZ

Above: *What a great blend of materials—to a tangerine-sherbet-colored organza scarf, Michelle added fringe made of an embossed iridescent plastic material (called Shimmer Sheetz), gold braid, bits of old jewelry, and real coral.*

Left: *Humble muslin was painted with diluted Dye-Na-Flow and dried. Decorative machine stitches—again, nothing fancy—were applied in meandering lines. Some metallic threads add a low-key sparkle. Gold cording accents the seams, while beads from an old "found" necklace keep company with pieces of real coral.*

SOURCE DIRECTORY

Listed below are the manufacturers and suppliers for many of the materials used in this book. Most of these companies sell their products exclusively to art supply and craft retailers, which are a consumer's most dependable sources for most art supplies. Your local retailer can advise you on purchases and can order a product for you if they don't have it in stock. If you can't find a store near you that carries a particular item or a specialized material or tool, this list contains other sources you can explore.

DYES & PAINTS

Createx, Inc.
14 Airport Park Road
East Granby, CT 06026
800-243-2712
www.CreatexColors.com

Dharma Trading Co.
P.O. Box 150916
San Rafael, CA 94915
800-542-5227
www.dharmatrading.com

Jacquard Products
P. O. Box 425
Healdsburg, CA 95448
800-442-0455
www.jacquardproducts.com

Moyer Design & Silk Painting
P. O. Box 2875
Fort Bragg, CA 95437
707-964-7077
www.moyerdesign.com

Plaid Enterprises, Inc.
3225 Westech Drive
Norcross, GA 30092
678-291-8100
www.plaidonline.com

PRO Chemical & Dye, Inc.

P. O. Box 14
Somerset, MA 02726
800-228-9993
www.prochemical.com

Silkpaint Corp.
P. O. Box 18
18220 Waldron Drive
Waldron, MO 64092
816-891-7774
www.silkpaint.com

Speedball Art Products
2226 Speedball Road
Statesville, NC 28677
704-838-1475
www.speedballart.com

Welsh Products, Inc.
932 Grant Street
Benicia, CA 94510
800-745-3255
www.welshproducts.com

FABRIC SUPPLIERS

Exotic Silks
1959 Leghorn
Mountain View, CA 94043
800-845-SILK
www.exoticsilk.com

Fairfield Processing Corp.
(pillow forms & batting)
P. O. Box 1157
Danbury, CT 06813-1157
800-980-8000
www.poly-fil.com

J. B. Martin Company, Inc.
10 East 53rd Street, Suite 3100
N.Y., NY 10022
800-223-0525
www.jbmartin.com

Silk Essentials, Inc
6 East 30th Street, 2nd Floor
N.Y., NY 10016
212-481-3843
www.silkessentialsfabrics.com

Testfabrics, Inc.
P. O. Box 26
15 Delaware Ave.
West Pittston, PA 18643
570-603-0432
www.testfabric.com

Thai Silks
252 State Street
Los Altos, CA 94022
800-722-7455
www.thaisilks.com

EMBELLISHMENTS & TRIMS

Boutique Trims
21200 Pontiac Trail
South Lyon, MI 48178
888-437-3888
www.BoutiqueTrims.com

Conso Products
513 North Duncan Bypass
Union, SC 29379
800-842-6676
www.conso.com

Margola Import Corp.
48 West 37th Street
N.Y., NY 10018
212-695-1115
www.margola.com

Zucker Feather Products
P.O. Box 331
California, MO 65018
573-796-2183
www.zuckerfeathers.com

INDEX